Secrets of
DRAWING
START TO FINISH

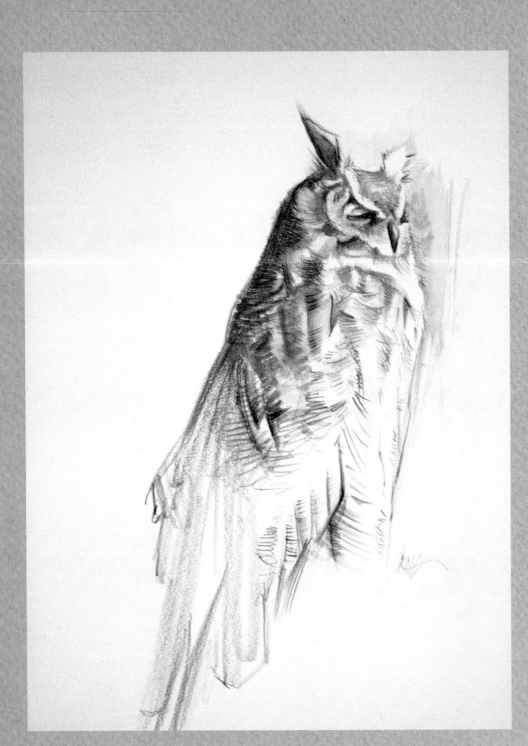

Old and Wise
Colored water-soluble pencil on bristol board
16" × 12" (41cm × 30cm)

❧ ESSENTIAL ARTIST TECHNIQUES ❧

Secrets of
DRAWING
START TO FINISH

Craig Nelson

NORTH LIGHT BOOKS
CINCINNATI, OHIO
www.artistsnetwork.com

CONTENTS

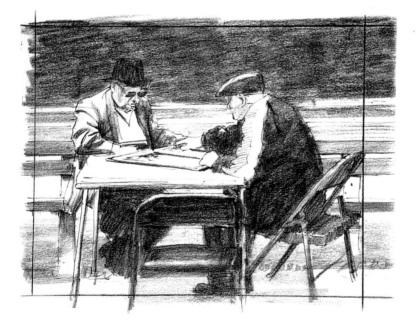

INTRODUCTION

Drawing is the one artistic endeavor that everyone has experienced at some-time. It was most likely the first written form of communication, and continues to be a favorite leisure activity.

It is the seemingly magical act of drawing that captivates the heart and imagination of so many. The thrill of making a group of marks to create an image offers a special sense of accomplishment. As a child matures, each new year brings a greater awareness of how to make those marks accurately reflect the subject he or she chooses to depict.

The act of drawing is timeless. Although mediums, techniques and concepts have changed, the use of marks and tones has always been the foundation on which drawings are made. Beginning with a blank page and ending with a pleasing image can be a rewarding experience. As in any endeavor, improvement comes with practice and repetition. Eye-hand coordination and sensitivity to mediums may be developed through experience.

Today, those who engage in the art form known as drawing work on a variety of levels. There are those who doodle, those who sketch for fun, those who draw for a living, and those who draw for the sheer aesthetic beauty of drawing. Whatever the motive, drawing is something that everyone can enjoy and grow with. It takes only desire and practice, practice and more practice. The satisfaction of creating an outstanding drawing is hard to beat, so pick up your pencils, pens, markers, charcoals or pastels and enjoy!

Two-Wheeler
Charcoal on toned Canson paper
16" × 12" (41cm × 30cm)

MEDIUMS AND MATERIALS

Just about anything that can make marks or tones may be used for drawing. The yellow-jacketed no. 2 graphite pencil with an eraser that we are all familiar with is usually our first drawing tool.

However, even graphite comes in various degrees of hardness, offering a variety of tones. There are many other types of mediums that all have unique characteristics and therefore offer unique drawing opportunities. Try as many as you can.

The Bachelor
4B and 6B charcoal on gray sketching paper
24" × 18" (61cm × 46cm)

Drawing Mediums and Tools

Drawing mediums are referred to as either dry
or wet. Both types can be combined in count-
less ways to produce everything from quick,
hard contour lines to rich, graceful gradations.

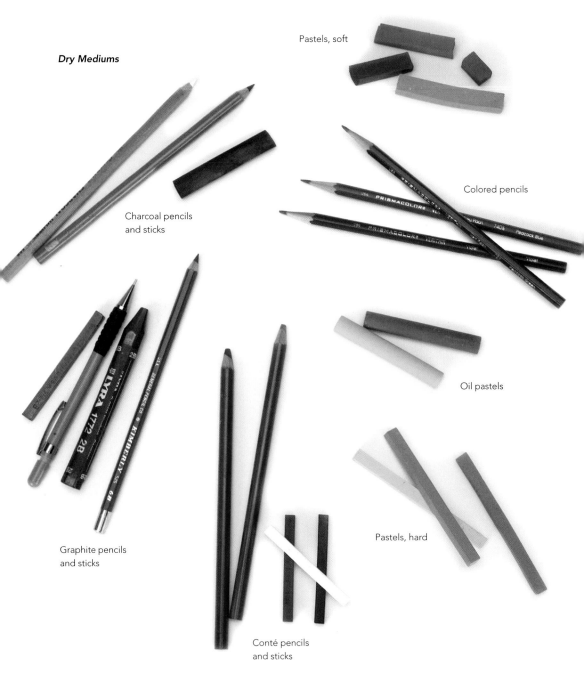

Pastels, soft

Dry Mediums

Charcoal pencils
and sticks

Colored pencils

Oil pastels

Graphite pencils
and sticks

Pastels, hard

Conté pencils
and sticks

Wet Mediums

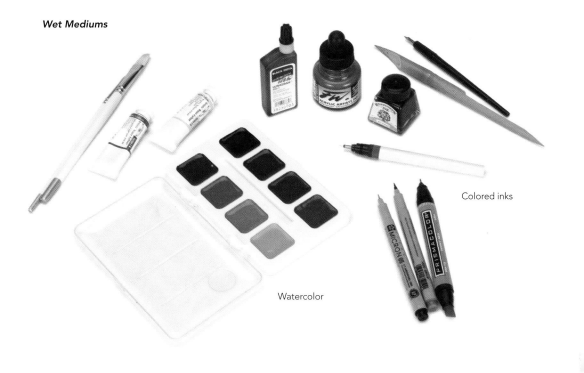

Colored inks

Watercolor

DRAWING TOOLS

The proper drawing tools combined with your chosen mediums and surfaces will help you achieve your artistic vision. Here are some tools you may find useful.

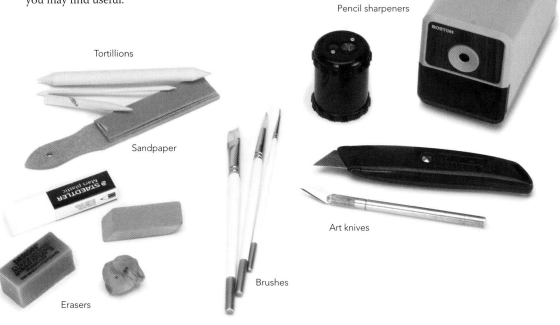

Pencil sharpeners

Tortillions

Sandpaper

Art knives

Brushes

Erasers

Characteristics

Artist's graphite is a combination of graphite and clay. It is a specific type of pencil that produces silvery blacks, and it comes in sticks as well as pencils. The higher the proportion of graphite to clay, the softer the medium.

Graphite comes in degrees of hardness from 8H to 6B (the *H* refers to hard and the *B* designates black). Hard graphite (H) is good for fine details. Soft graphite (B) can produce a wider range of tones than hard graphite and is good for large tonal areas. Soft graphite requires sharpening more often than hard.

Forms of Graphite
Pencils are best for detailed work while graphite sticks are good for creating large tonal areas. Mechanical pencils, for which a variety of leads are available, are a favorite of many artists.

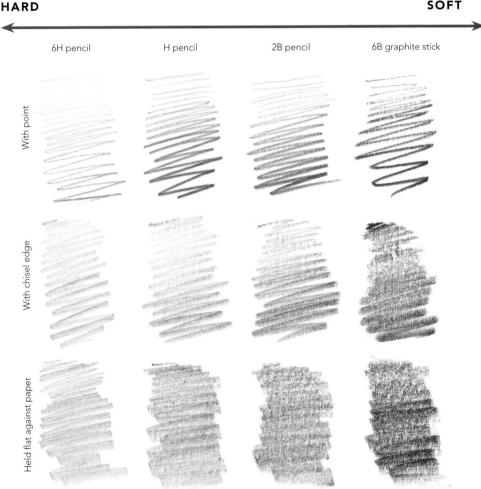

HARD **SOFT**

	6H pencil	H pencil	2B pencil	6B graphite stick
With point				
With chisel edge				
Held flat against paper				

Techniques

LIFTING OUT

The complement of the graphite pencil is the eraser. A kneaded eraser is pliable and is great for picking out soft whites. The hard eraser is better for adding crisp whites.

HATCHING AND CROSSHATCHING

Hatching is a closely spaced series of lines, usually parallel. Hatching is used for shading, shaping and building texture.

Crosshatching is hatching done in layers so that the lines intersect each other. By adding layers of crosshatching, you can increase the density and darken the value in small increments. This makes crosshatching an ideal technique for creating shadows.

Lifting Out

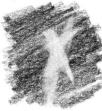

2H | 6B

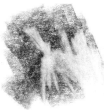

HB | Graphite stick

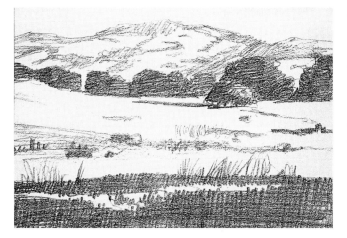

A Quick Graphite Sketch With Crosshatching
Solid tonal shapes and rapid lines make up this sketch. A few soft tones here and there make this a more accurate depiction.

Hillside Landscape
Graphite on ledger paper
5" × 7" (13cm × 18cm)

Characteristics

Charcoal's incredibly rich blacks make it a seductive medium. Since charcoal marks are easily made and can be quite broad, charcoal lends itself to large drawings. Charcoal sticks and pencils are made of compressed charcoal. There is also a softer variety called vine charcoal, useful for sketching.

Compressed charcoal, like graphite, comes in varying degrees of hardness. The 2HB through 6B are generally the most desirable.

Charcoal sticks are good for laying down wide strokes, while pencils are better for delicate work. Charcoal pencils are encased in either wood or paper and are less messy than sticks.

Vine Charcoal

Compressed Charcoal

White Charcoal on Black Paper

Charcoal Pencil

Other Materials for Working With Charcoal

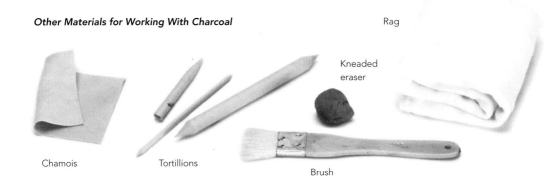

Rag

Kneaded eraser

Chamois

Tortillions

Brush

Techniques

Charcoal is easily blended with tortillions, facial tissue, chamois or even your fingers. As with graphite, you can subtract lines or tone from charcoal by lifting with an eraser.

Because charcoal is soft, the *tooth*, (texture) of your paper greatly affects the look of charcoal marks. Use spray fixative to keep finished charcoal work from smudging.

Vine Charcoal

| Lines | Blended | Lifted |

Compressed Charcoal

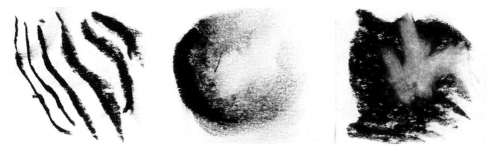

| Lines | Blended | Lifted |

Take Some of the Mess Out of Charcoal

Wrap charcoal sticks in paper towels or aluminum foil to keep your fingers clean.

Paper towels

Characteristics

Conté is the trademark name for a chalklike drawing medium. The most familiar Conté colors are rich, warm earth tones, from reddish sanguines to deeper umbers and blacks. For years Conté has been closely associated with figure drawing.

CHARACTERISTICS

Like graphite and charcoal, Conté comes in sticks and pencils and in varying degrees of hardness and softness. Conté also comes in different colors: black, white, brown umber (bistre), gray, sanguine orange, sanguine brown and sanguine red.

Fine Conté Lines

The shape of a Conté pencil allows you to create lines of varying width. If you want to create thin lines, use the edge of the pencil.

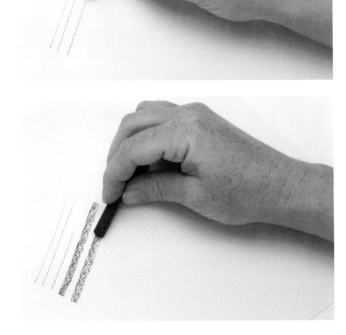

Thick Conté Lines

To vary the size of the lines of Conté sticks, change the angle at which the stick hits the paper. Although you can make wide lines with pencils, they will not be as dark as those made with Conté sticks.

Techniques

Conté has a dry, chalklike feel similar to charcoal. The more pressure you use with Conté, the darker the mark. You might begin a Conté drawing with a lighter color and softer lines and progress to darker colors and more powerful marks. White Conté is good for adding lights on toned papers.

Conté Can Appear Glossy

The harder varieties of Conté can display a rather glossy look—particularly the black.

Blending Conté

You can let your Conté marks show the texture of the paper, or you can blend them with a tortillion for a smooth look.

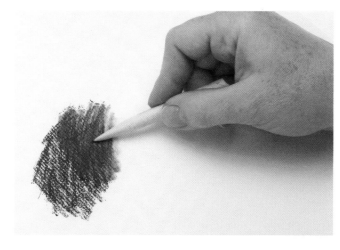

| White over red | White and gray over red | Red over black |

Combining Conté Colors

Just a few Conté colors can be blended to produce a variety of effects.

Characteristics

Soft colored pencils provide opaque coverage of the paper surface, and they excel at producing smooth, vivid color. Hard colored pencils have thinner leads that can be sharpened to a fine point, allowing for crisp lines but not for heavy coverage. You can use both kinds in one composition.

With water-soluble colored pencils, you can create fuzzy marks or flowing, luminous washes of color simply by adding water with a brush.

Choosing a Size for Your Colored Pencil Work

You might prefer to work smaller when using colored pencil than with other mediums. Completing a large, detailed colored pencil piece can be time-consuming. Of course, a loose gesture sketch in colored pencil would take less time.

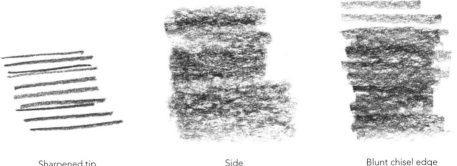

Sharpened tip Side Blunt chisel edge

Colored Pencil Strokes
Colored pencils can make a wide range of strokes depending on how sharp your pencil is and at what angle you hold it to the paper.

Water-Soluble Colored Pencils
You can soften strokes of water-soluble colored pencil with a brush and clear water.

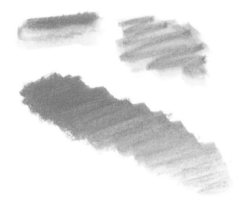

Techniques

BASIC STROKES

Colored pencil strokes can be light or dark, crisp or feathered, delicate or defined.

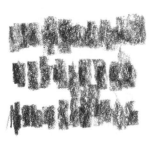

Choppy

Run the pencil at an angle across paper or a sanding block to achieve a blunt, slanted, "chisel" edge. Use this edge to make firm, short strokes.

Feathered

For feathered strokes, let your pressure on the pencil trail off at the end of the stroke. The result is a gently faded edge.

Tonal Variation

For a gradated tone, increase or decrease your pressure on the pencil as you work across an area.

Defined

A defined stroke has a clear start and stop with no feathering.

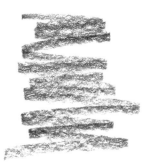

Your Colored Pencil Palette

Generally two or three each of yellows, oranges, reds, blues, greens and earth tones will suffice, with the addition of one or two flesh tones and possibly black and white.

Blending With Colored Pencils

A variety of blending techniques can be used to produce shading or to combine colors.

Burnishing
Apply layers of color with firm pressure to achieve an opaque, shiny look.

Layering
With light to medium pressure, lay one color atop another.

Crosshatching
Apply one color with parallel strokes, then add other colors similarly but at different angles.

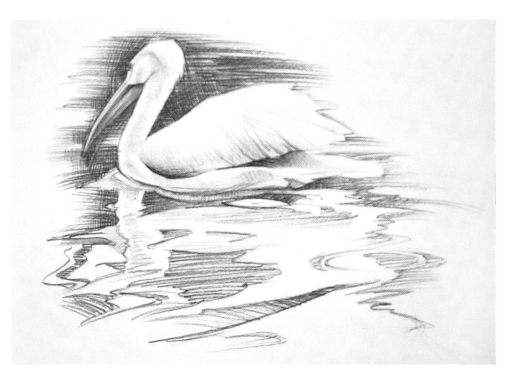

Crosshatched Colored Pencil
The white of the paper is surrounded by blues in a crosshatched effect combined with a group of free gestural curves. The orange acts as visual punctuation.

White Reflection
Colored pencil on ledger paper
11" × 15" (28cm × 38cm)

Characteristics

Pastels are made from a combination of chalk, pigment and a binder (usually gum tragacanth) that has been formed into sticks or pencils. The binder holds the pigments together, but pastel needs a paper with a lot of tooth to remain on the surface.

HARD PASTELS

Hard pastels are usually rectangular. Because they contain more binder than soft pastels, they tend to break less often and emit less dust. Sharpened hard pastels are great for linework.

Turned on their sides, hard pastels can be used to create broad areas of color, a useful technique for applying the initial layers of color for a picture.

SOFT PASTELS

Soft pastels tend to be rounder than hard ones and usually are enclosed in a paper sleeve to help prevent breakage. Because they have less binder, soft pastels create more dust and are more easily broken.

Pastel on Cold-Pressed Watercolor Paper

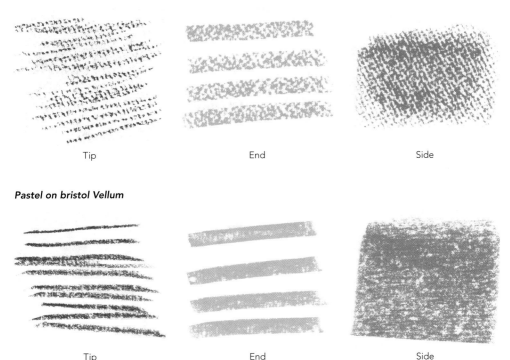

Tip End Side

Pastel on bristol Vellum

Tip End Side

Techniques

WAYS TO BLEND COLORS

Pastels can be blended with fingers, a tortillion or (for large areas) a rag.

Mingling pastel colors without blending them lets the colors combine visually for a textured effect. A few different ways of doing this:

- *Layering.* Apply one color atop another without blending.
- *Crosshatching.* Apply lines of color at different angles.
- *Scumbling.* Apply one color over another in loose, wide strokes.

Blended

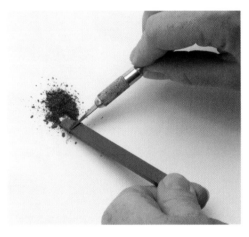

Sharpening a Pastel Stick
To sharpen the edge of a pastel stick, scrape it with an art knife. Use this technique to sharpen Conté sticks, too.

Layered

Crosshatched

Scumbled

Characteristics

BALLPOINT PENS

Although most commonly used for writing, ballpoint pens are great for quick sketches or for transferring a drawing. Most ballpoint pens are not permanent.

FINE-LINE DRAWING PENS

There is a terrific variety of permanent fine-line drawing pens. A .03 size is probably the best for drawings 11" × 14" (28cm × 36cm) or smaller. However, it is possible to create exciting drawings with bolder pens.

Drawing Pens

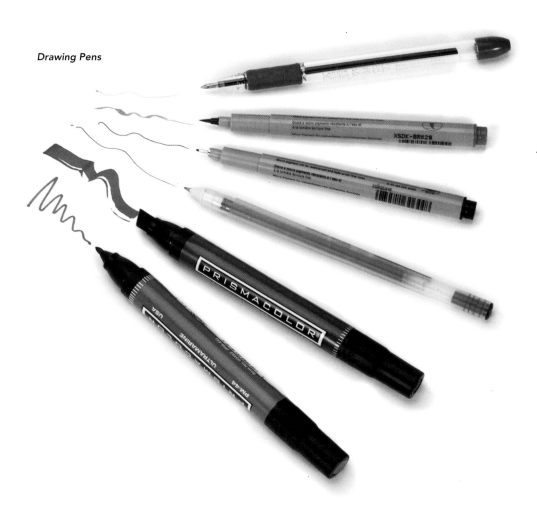

TECHNICAL PENS

Technical pens come in three types:

- *Refillable.* This has a plastic cartridge you fill with your choice of ink. You can also choose from a range of point sizes.
- *Disposable cartridge.* This has a plastic cartridge already filled with ink that you replace when empty.
- *Disposable pen.* Throw out the entire pen when it's empty.

FELT-TIP PENS

Felt-tip pens come in various sizes and colors. Experiment to find the pen that works best for you.

BRUSH PENS

Brush pens have a flexible, fibrous point. The pen can make lines of varied widths from fine to broad, like a round paintbrush.

Cleaning Technical Pens

Keeping your technical pens clean is extremely important. Follow the instructions that accompany the pen for specific cleaning techniques.

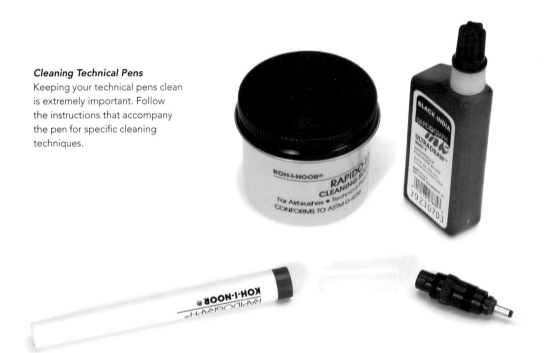

Techniques

USING PEN

There are two basic types of marks you can make with pen: dots or lines. You can vary both types of marks in size, volume and arrange-ment. The marks will seem lighter if they are spaced farther apart and will seem darker if they are close together.

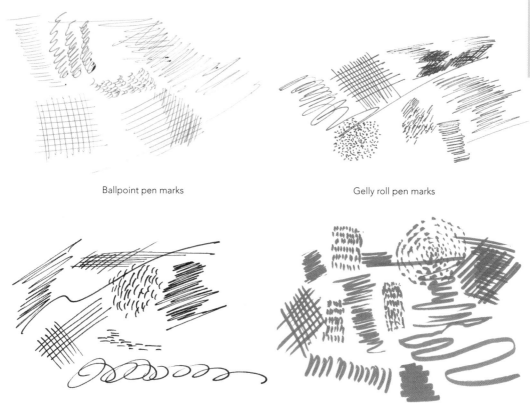

Ballpoint pen marks

Gelly roll pen marks

Fine-Line pen marks

Artists' pen marks

Different Marks Made With Pens

Different types of drawing pens have unique characteristics and will make the same types of marks in slightly different ways. Experiment to find the drawing pen that best suits your purpose.

Characteristics

DIP PENS

Dip pens do not have a built-in ink reservoir and must be dipped into a container of ink to pick up a new supply. Their steel nibs are removeable and come in many shapes, giving you a range of possible marks.

BAMBOO PENS

These dip pens are made from a slender stick of bamboo. The bamboo is sharpened to a point and split, creating a reservoir for the ink.

ORIENTAL BRUSHES

These are brushes that lend themselves well to drawing with ink. You can get soft, medium and hard tips.

CALLIGRAPHY BRUSHES AND PENS

There are a variety of brushes and pens that are used for calligraphy. The brushes come in many shapes and sizes, and the pens have a variety of nibs to create different ornamental effects.

Inks and Dip Pens

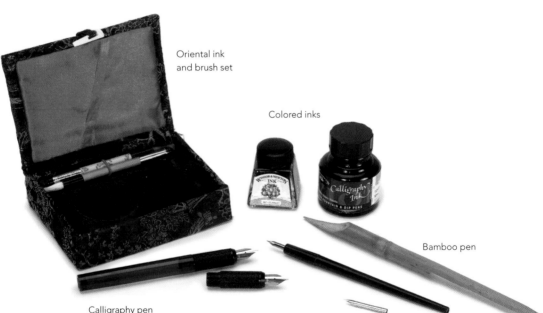

Oriental ink and brush set

Colored inks

Bamboo pen

Calligraphy pen

Dip pen with nibs

BLACK INKS

These are made up of fine carbon pigments. When buying black ink, look for a manufacturer's date on the container. Inks that have sat on the shelf for longer than two years may have separated and therefore will not be suitable for use.

COLORED DYE-BASED INKS

Many colored inks are made of impermanent dyes and should therefore be used only for work that does not demand permanence.

COLORED PIGMENTED INKS

These inks work well in technical pens as long as you choose colors that are labeled as transparent.

Inks

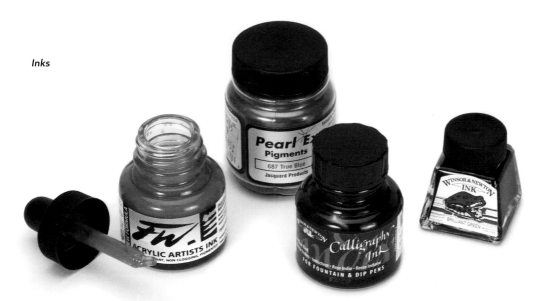

A Starter Ink Set

I recommend purchasing two earth tones (one dark, one warm), plus one each of yellow, red, blue, green and black. To add interest, you can also add one or two more colors of shocking intensity.

Techniques

You can use many of the same techniques with ink as you can with drawing pens. What you use to apply the ink greatly affects the way the ink looks on your drawing surface.

Choose the Right Ink

When you're selecting inks, your drawing surface should also be a consideration. Some inks are made for particular types of surfaces. Be sure to read the labels carefully before you buy.

Ink applied with a brush

Ink applied with a pen

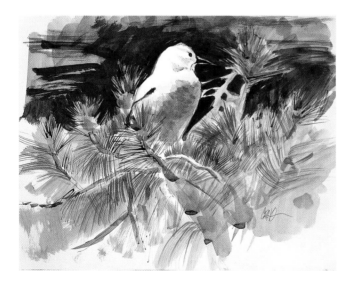

Enhance Basic Shapes With Line

Refine the pine needles by using hog-bristle brushes to apply darker greens onto the light green field.

Nestled in the Pines

Colored inks on
bristol board
11" × 14" (28cm × 36cm)

Drawing Surfaces

The surface you choose for your artwork will contribute greatly to the character of the finished piece. A coarse surface may enhance certain mediums, bringing out the texture and adding variety to the tones. A smooth surface may be more appropriate if you don't want the marks you make to have textured apprearance.

Drawing Surfaces

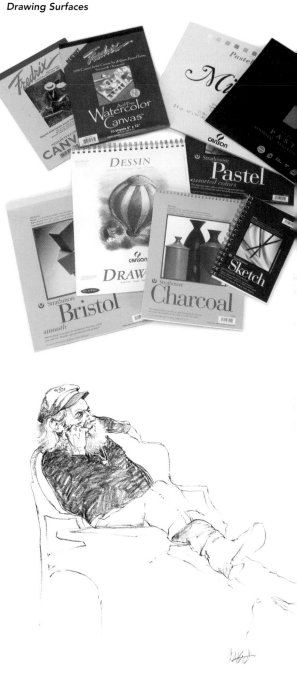

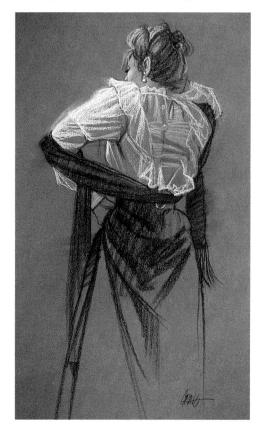

Dark Canson Paper
On dark paper, the white pastel dominates and the dark charcoal supports.

White Bond Paper
Charcoal on simple white bond paper, the most commonly used white paper.

Paper

Choose paper that is acid-free to ensure a long life for your artwork. Also be aware that heavier papers withstand erasing, scratching and rubbing better than lighter papers and do not warp as easily.

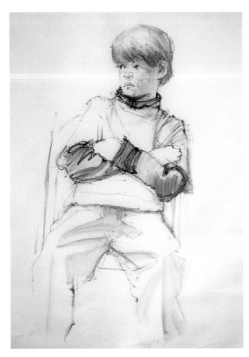

Brendan's Cool Shirt
Oil pastel on vellum
25" × 19" (63cm × 48cm)

From left to right: vellum, charcoal paper, pastel paper (2)

CHARCOAL PAPER
Charcoal paper comes in varying degrees of tooth. Although designed for charcoal drawings, you can use it with other mediums such as pastels.

VELLUM
Vellum is a nonporous surface with a slight tooth. It is a good surface for pen-and-ink work, graphite sketches and for oil pastels.

PASTEL PAPER
Like charcoal paper, pastel paper comes in different degress of tooth and an also be used with other mediums.

WATERCOLOR PAPER
The surface of a paper influences the look of the medium you apply to it. Watercolor paper, best suited for wet mediums, comes in three textures:
- *Hot-pressed.* This has a very smooth surface.
- *Cold-pressed.* This is moderately textured.
- *Rough.* This is highly textured.

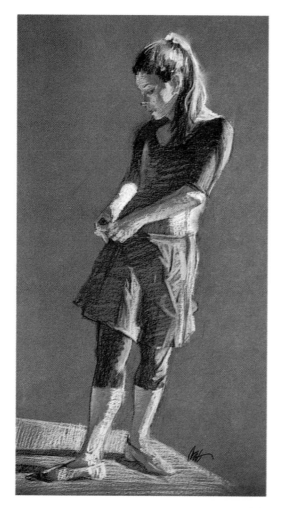

Fixing Her Skirt
Soft pastel and black charcoal pencil
on Canson paper
20" × 12" (51cm × 30cm)

From left to right: rough,
hot-pressed, cold-pressed

Board

Boards are a great option for drawing, especially when working with wet mediums. They are thicker and therefore less likely to warp when washes are applied.

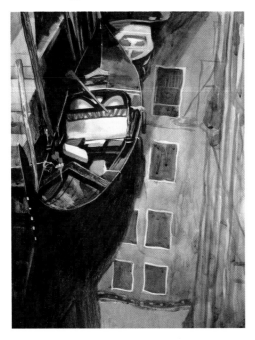

WATERCOLOR BOARD

Watercolor board is watercolor paper glued to a stiff backing of cardboard. Like the paper, watercolor board comes in hot-pressed, cold-pressed and rough textures.

BRISTOL BOARD

Bristol board is created by compressing two or more pieces of paper together. The more paper used, the heavier the weight of the board.

MAT BOARD

Mat board is a type of cardboard that comes in a wide variety of colors and textures. It can be used for drawing or as the border around a framed picture.

From left to right: watercolor board, mat board, bristol board,

Gessoed Board
The nonabsorbent quality of gesso is a bit rough, great for textural charcoal and for wash-like stains which can be layered to build varying grays.

Lone Gondola
Graphite, acrylic, colored pencil and gesso on illustration board
20" × 16" (41cm × 51cm)

Other Types of Surfaces

Exploring other types of surfaces is a lot of fun. Surfaces such as canvas, Yupo and foamcore board can provide exciting and inspirational results.

CANVAS

Canvas may be purchased in roll form, pre-stretched on stretcher strips or mounted on a stiff backing of cardboard or hardboard. It can also be found raw or primed. You can draw on it, but canvas is best suited for oil and acrylic paintings.

SKETCH PAPER AND NEWSPRINT

Inexpensive sketch paper and newsprint are useful for doing quick idea sketches but they should not be used for finished art as neither one will last. Newsprint is especially problematic because its high acid content will cause your art to quickly fade.

FOAMCORE

Foamcore is a strong, stiff, lightweight board of plastic fibers with paper laminated on both sides. It comes in many colors and thicknesses. Foamcore is often used as a backing for papers and other surfaces, but can be drawn on, too.

YUPO

Yupo may best be described as plastic paper. It's most often used for big, bold watercolors. Yupo is acid-free and archival, but you should spray your work with fixative to prevent the image from smearing.

From left to right: sketch paper, canvas, Yupo, foamcore

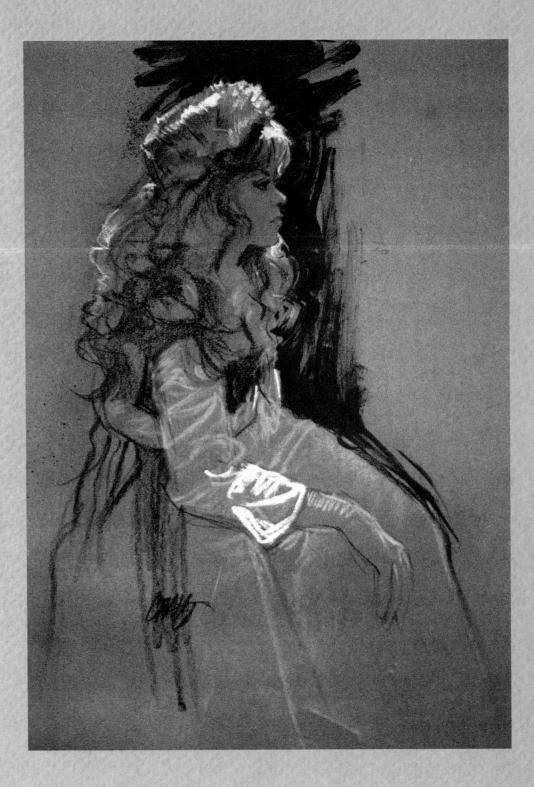

LINE AND TONE

When most people think of drawing they envision linework only, without considering the tones we usually associate with painting and photography. However, all of these forms of representational art rely on proportions, perspective and composition. A variety of drawing possibilities opens up when line and tone are combined.

The Fur Cap
Charcoal pastel and oil on toned Canson paper
24" × 18" (61cm × 46cm)

Working With Line and Tone

Generally it is more aesthetically pleasing, for either line or tone to dominate a drawing while the other provides the accent. A drawing may consist primarily of line with tone as an accent, or a drawing may be made up of tone accented by line. Use the accent in the drawing's focal point or in an area to which you wish to call more attention.

You may use a variety of mediums in line and tone drawings, or only one. Utilizing both line and tone in your drawings allows you to explore and discover new directions for your work. Starting with line and then adding tone, or developing a group of tones and then unifying it with line can help you express your ideas more fully. Your ability to work with

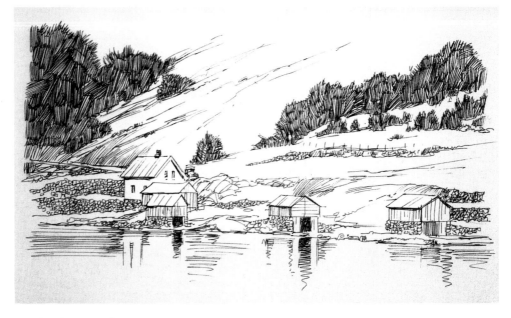

Line Can Serve as a Contrast to Tone
This ink sketch uses line and tone to establish the contrast between the geometric architecture forms and the organic landscape forms.

Along a Fjord
Fine-line pen on vellum
11" × 14" (28cm × 36cm)

different mediums, approaches and technical applications will improve with practice and repetition. As you experiment you will discover exciting new methods; practice will make you comfortable with them.

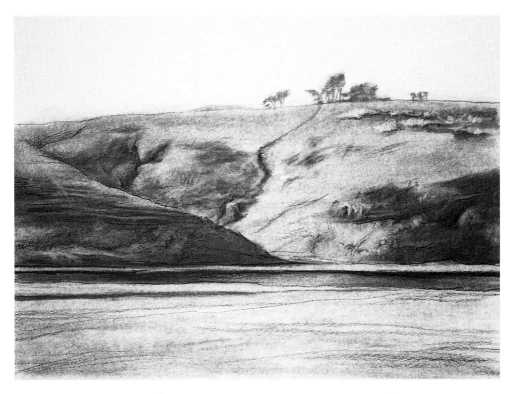

Lines Can Bring Unity to a Tonal Drawing
This drawing is predominantly tonal. Linear accents clean up the toned edges, adding definition and refinement.

Marin Hills
Charcoal on vellum
18" × 24" (46cm × 61cm)

Hard-Line Drawings

Line drawings are primarily *contour drawings*. Here, *contour* refers to edges, either exterior edges or interior edges (such as those around belts, collars, eyes and other features). Hard-line drawings may be precise and formal, or fluid and casual. Pen lines may be thick or thin. Brush, stick or quill lines may vary from thick to thin as well.

Using line exclusively to create a drawing may seem limiting, but if employed creatively, you can achieve a variety of interesting and charming effects. With practice, your line-drawing ability will develop and become a very satisfying method for creating details.

Draw With Confidence
This hard-line drawing shows fluidity, conviction and confidence. The artist betrays no fear of making mistakes.

The Girl in the Hat
Fine-line marker on bristol board
14" × 9" (36cm × 23cm)

Exterior Contours and Interior Lines

It is possible for a line to begin as an exterior contour and move into an interior line. This may be seen in folds of clothing or in anatomical features.

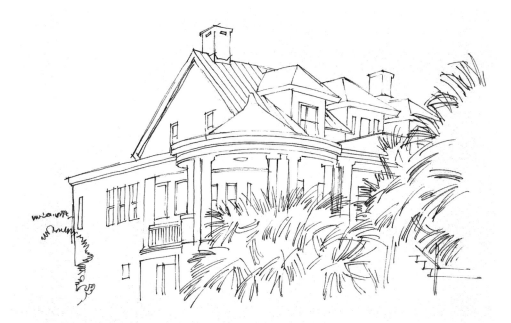

Creating Detail With Line
This pen sketch relies upon line to delineate the features and characteristics of the foliage-covered house.

South Carolina House
Fine-line technical pen on vellum
9" × 12" (23cm × 30cm)

Hold Your Pen Properly for a Better Drawing
It is important to draw in a free and comfortable fashion. Do not grip your pen tightly, using only your wrist. Instead, keep your arm involved in your drawing. Don't draw as if you are writing; this will result in a stiff drawing devoid of feeling.

Soft-Line Drawings

Soft-line drawings, such as those done with graphite or charcoal pencil, may consist of neat, crisp lines and soft lines that seem to just fade away. The beauty of soft-line drawings is in the variations of line work you can achieve.

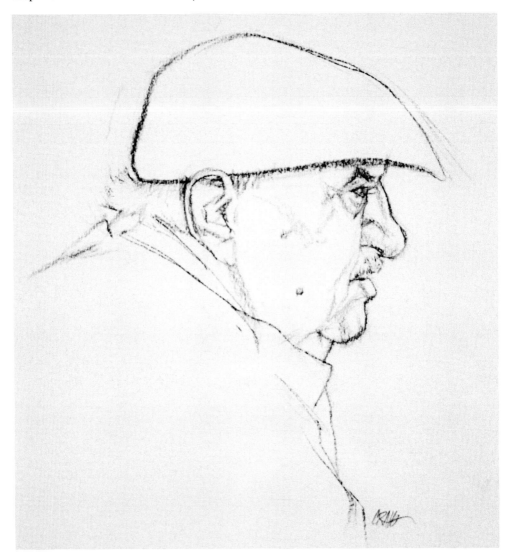

Drawing With Soft Lines
This soft-line drawing employs the variety of line qualities available with charcoal.

An Interesting Profile
Charcoal pencil on ledger paper
10" × 10" (25cm × 25cm)

Combining Hard and Soft Lines

You can make your line drawings more interesting by combing hard and soft lines. Soft lead pencils such as graphite and charcoal are especially good for creating both hard and soft lines. This type of drawing lends itself to more spontaneous compositions, without the use of tone.

The feeling of a hard-and-soft line drawing is usually somewhat carefree. It is important to realize that all line characteristics come from you and your response to your subject.

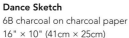

Dance Sketch
6B charcoal on charcoal paper
16" × 10" (41cm × 25cm)

Detail of Hard and Soft Lines

Combining Hard and Soft Lines

To create variations from hard to soft lines in a drawing:
- Hold the drawing tool loosely. This will enable you to use either the tip or the side.
- Vary the pressure. More pressure will create darker lines and less pressure will create lighter lines.
- Vary the speed with which you make lines to control the precision and character of the line.

Contour Lines

Contour lines define edges. The contour of something is its outside edge or shape. However, specific features within larger shapes also have contour, including folds, eyes, ears and hair lines. All these may be described by simple line.

Drawings consisting solely of contour lines must rely upon the correct application of the principles of proportion, perspective and gesture to be successful. Accuracy with these elements will be extremely helpful to the viewer because, without tone, it might otherwise be difficult to "read" the drawing. Pale sketch lines will help you achieve correct proportions and perspective. Hold your drawing tool with a sensitive, delicate grip. You should feel the drawing tool make the mark, but you should not press so hard that you etch the marks into your surface.

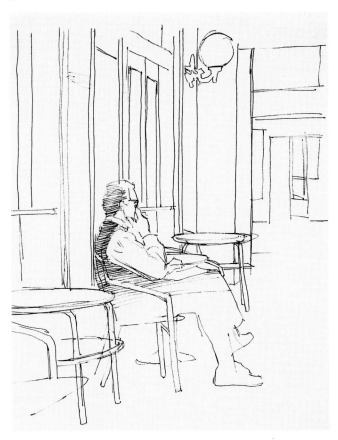

Sketch of Contour Lines
In this sketch I drew mostly contour lines but added a minimal amount of hatching to indicate tones in the focal point.

Sketch for Outdoor Cafe
Fine-line pen on vellum
12" × 9" (30cm × 23cm)

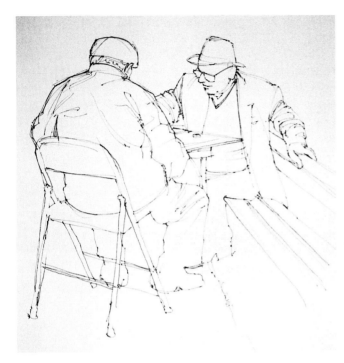

Contour Line Drawing
This drawing relies completely on contour lines. Shapes and proportions are crucial to the readability of the drawing. An indication of a few folds prevents the drawing from seeming incomplete and gives the drawing a bit of authenticity.

A Game in the Park
Fine-line pen on ledger paper
16" × 12" (30cm × 41cm)

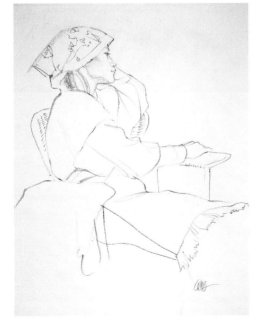

Contour Is an Important Part of a Successful Drawing
This soft contour drawing consists of crisp and soft lines defining a variety of contours. Using only the lines most essential creates a pleasing line quality.

The Asian Girl
Conté and charcoal on bond paper
24" × 18" (61cm × 46cm)

Descriptive Lines

Generally speaking, descriptive lines are used to convey details. It is possible to enhance contour with descriptive lines. Careful linework may be used to describe smaller details or textural characteristics that would be difficult to convey with tone.

Descriptive linework may take the form of a group of close lines used to show off a specific subtle texture, or a few careful lines describing folds in a shirt or other fabric.

Closely Examine Your Subject
Examine your subject carefully as you decide what to describe and how to describe it.

Beat-Up Brush
Graphite pencil on ledger paper
10" × 8" (25cm × 20cm)

Detail of close lines

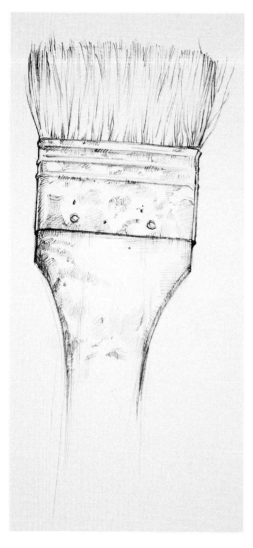

WHAT TO USE

Mediums used for descriptive linework should have a good sharp point. Fine-line pens or neatly sharpened graphite or charcoal pencils will work best. A sand pad is helpful to keep pencils pointed for a more precise line.

Carefully choosing what to describe and how to describe it with your chosen medium will also help to bring about a successful descriptive drawing.

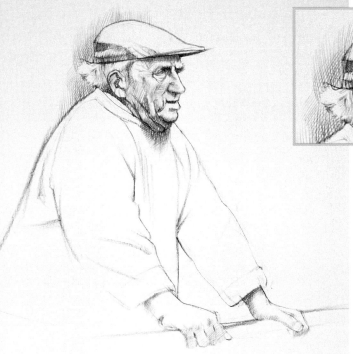

Detail of descriptive line drawing

Choose an Effective Medium
This drawing was done with charcoal pencils. Keeping the point of the pencil sharp was necessary for the detail.

Cotswold Man
Charcoal pencil on ledger paper
14" × 11" (36cm × 28cm)

Keep the point sharp for descriptive linework

Line Variations

Various line techniques such as scribbling, hatching, pressing hard or barely pressing, all may achieve interesting effects. Using exterior and interior contours will keep your drawing from looking like a simple outline.

Perhaps the most important factor in a successful line drawing is knowing what to leave out.

"Editing" is absolutely necessary to a successful line drawing. Too many lines or too much detail can overwhelm the viewer and overshadow your focal point. Try using soft interior lines as an accent to hard contour lines. Varying the lines will add interest to your drawing.

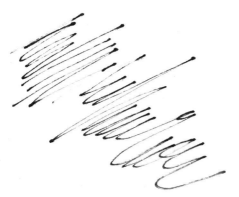

Scribbling

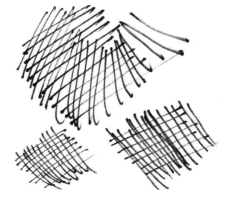

Hatching

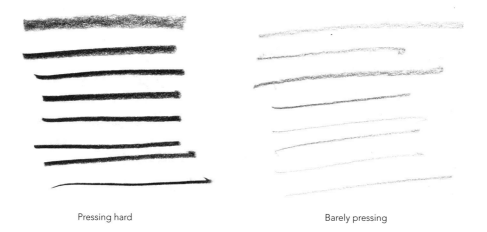

Pressing hard

Barely pressing

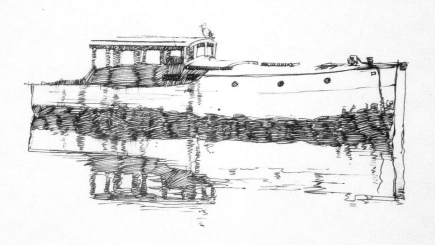

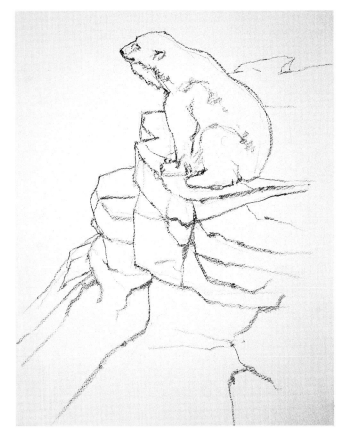

Use Varied Techniques to Enhance Line
The hard line is enhanced with some strategic hatching, creating a slightly tonal feeling.

A Simple Boat
Fine-line pen on vellum
8" × 12" (20cm × 30cm)

Line Drawing Offers Many Creative Possibilities
This is a very casual line sketch of the bear. It exhibits a lot of fluidity and freedom.

Polar Bear
Charcoal pencil on charcoal paper
18" × 14" (46cm × 36cm)

Tone

Tone is the term artists use to refer to color and value in the areas between contour lines. Tone covers a broader area than a line and offers more possibilities for variation in value. Tonal drawings define shapes with areas of contrasting value rather than with definite, hard contour lines—the same way our eyes distinguish shapes. Adding tonal values to a sketch can make objects appear more three-dimensional, enhancing form and increasing the viewer's ability to "read" a drawing. Tone may be applied with dry medium such as charcoal or pastel, or it may be added with a wet medium such as an ink wash. The drawing surface itself may also add tone to the artwork.

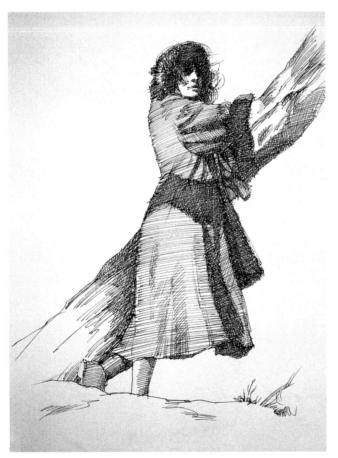

Use a Variety of Tones
Here I used hatching to create the variety of tones in this drawing. To establish the dark areas, I simply layer the hatching.

An Offshore Breeze
Fine-line technical pen on bristol board
12" × 9" (30cm × 23cm)

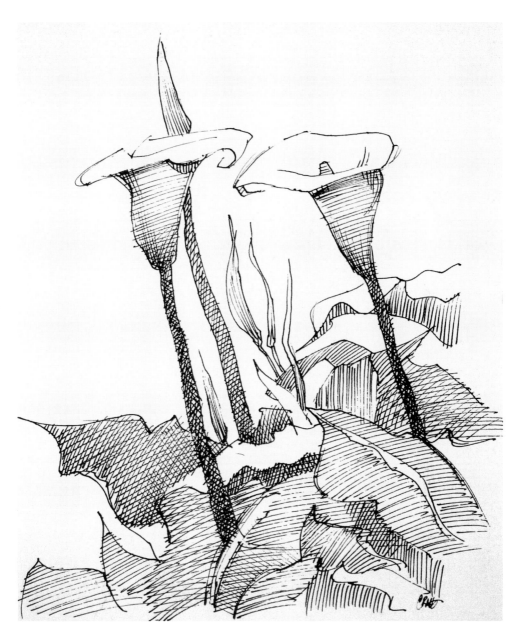

A Tonal Sketch
In this quick tonal sketch the hatching is coarse and abbreviated to quickly establish the placement of different tonal values. This establishes the shape of the lilies.

Lilies
Fine-line technical pen on bristol board
10" × 8" (25cm × 20cm)

Value

Value is the degree of lightness or darkness of a specific tone. Black is at one end of the value scale and white is at the other, with all shades of gray in between. Each color has a corresponding value scale with similar gradations.

Contrasts and variations in value may be used in drawings for many purposes. Value variations can describe and model form, and contrasting values can define shape. Value contrasts may be used to accent an area or draw attention to a specific part of the drawing.

Whether used in conjunction with a line drawing or all by themselves as a tonal drawing, value variations give weight to a composition, create form and establish a three-dimensional quality.

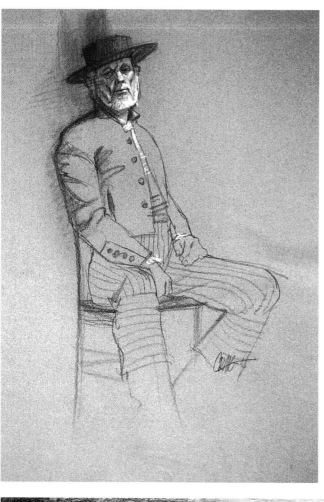

Value Adds Richness
This loose charcoal line drawing has been enriched through the use of value variation. The gray-tone Canson paper acts as a middle value to set off both the dark charcoal and the light Conté.

Spanish Dancer
Charcoal and Conté on Canson paper
18" × 24" (46cm × 61cm)

USE A RANGE OF VALUES

When creating a range of value for your drawings, gradually build the tones from the lightest to the darkest by applying a darker tone on top of a lighter tone. Using your subject as a reference, continue building layers as required until you reach the extreme darks. This will give you more control over the value range you create.

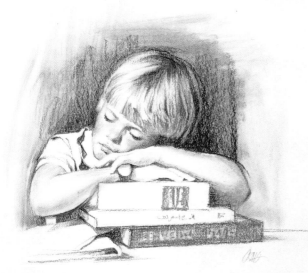

Build Darker Values On Top of Lighter Tones
I chose to use a sanguine pencil for the first tonal layer. Then, I applied charcoal on top to create the darker values.

The Napping Student
CarbOthello pencil and charcoal pencil on vellum
12" × 14" (30cm × 36cm)

Building Up Tones
Start with lighter tones and layer to make the value darker.

Using Value to Create Form

You create form in a drawing by using value to depict light and shadow. Develop value variations carefully and slowly, and only after carefully observing the tones on the subject itself. Be sure to consider the character of your subject. For example, round or soft, turning forms will have a soft, gradual value change, while sharper edges will have a crisp, abrupt value change.

It is also vital to consider the location of your light source when using value variations to model forms and create shadows. Be sure that your highlights and shadows are located consistent with the direction of the light. Also consider the differences between types of shadows. *Form shadows* are those dark areas on the side of an object where the light does not hit; *cast shadows* are those dark areas where the light has been blocked by another object.

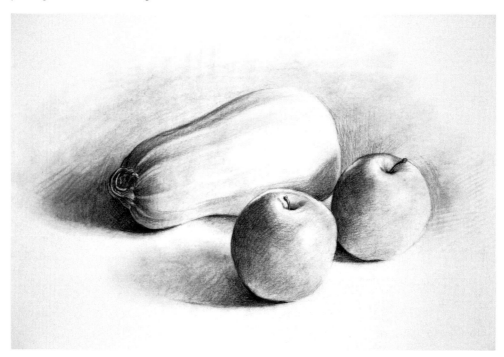

Light and Shadow Are Necessary to Create Form
The three relatively simple forms here (a squash and two apples) are all light in value. This enables shadow tones to show well. A single light source helps define the forms.

Three Part Composition
Charcoal on bristol board
12" × 18" (30cm × 46cm)

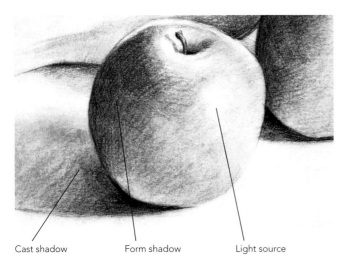

Cast shadow **Form shadow** **Light source**

Detail of Apple

The form shadows in the apple goes from light to dark as the light source gets further away. A similar principle applies to the cast shadows, only they get lighter the farther they get from the object.

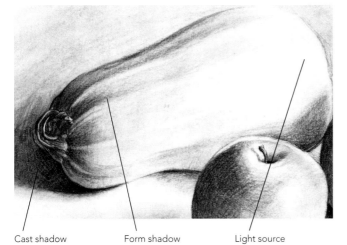

Cast shadow **Form shadow** **Light source**

Detail of Squash

For the squash, I use form shadows to create the effect of the ridges. Notice how the top of the ridges are lighter (where the light hits) while the bottom part of the ridge is darker. I also gradually darken the values to give more shape to the ridges.

Use a Single Light Source

To make value changes on your subject easier to see, shine one light directly on your subject and block out other unnecessary light.

Positive and Negative Shapes

When you're drawing, it's natural to want to concentrate on the *positive space* that is, the shape of the actual object or objects you're trying to draw. It's less natural, yet just as important, to draw the *negative space*, or the shapes surrounding an object. Every drawing has positive and negative spaces, and both must be well rendered for your drawing to be successful.

Draw the Positive and the Negative Shapes
In this sketch, the trees are the positive spaces and the lighter areas around them are the negative spaces. As you draw, look at the shapes created by the positive and negative spaces. Both should form the basis of your sketch.

Eucalyptus Sketch
Soft charcoal pencil on rough drawing paper
11" × 12" (28cm × 30cm)

Positive shapes Negative shapes

Use Contour to Render Positive and Negative Shapes

In *Eucalyptus Sketch*, I used tone to establish positive and negative shapes. Here I used contour lines to capture the relationship of positive and negative shapes.

Understanding Light and Shadow

Our eyes depend on light and shadow to define form, so it is important to understand the basic properties of light and shadow to create form in drawing.

Most objects you portray with tone and value will exhibit the following:

- *Form light*. The area facing and struck by the light. This producing the lightest part, or *highlight*, of the object.
- *Form shadow*. The area where light does not hit.
- *Hard edge*. A characteristic of forms with crisp, well-defined edges.
- *Soft edge*. A characteristic of rounded forms where edges are not clearly defined.
- *Cast shadow*. The shadow created on a surface when the light on the surface is blocked by another object. It is usually hard-edged.
- *Reflected light*. Lighter areas within a form shadow, created when a bit of light is reflected back onto it.
- *Core shadow*. The darkest part of a form shadow, not affected by reflected light.

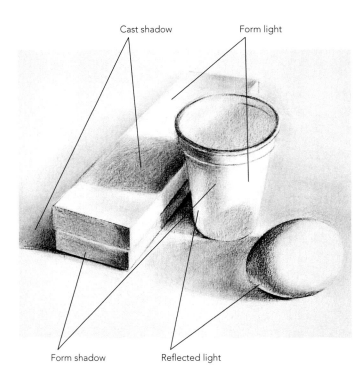

Cast shadow Form light

Form shadow Reflected light

Different Aspects of Light and Shadow
These three simple white forms show the various aspects of light and shadow modeling. White objects work best for this because there is no local color variation to interfere.

White Forms
Charcoal on heavy bond paper
10" × 16" (25cm × 41cm)

Lost and Found Edges

In order to add a dramatic effect to a drawing, use the concept of *lost* and *found edges*. A lost edge occurs where the edge of the form seems to disappear into the background. You lose light edges in a light space or dark edges in a dark area. Basically, a lost edge fades into an area with a similar value, while a found edge relies upon contrasting values to define it.

One strong light source and a dark background will provide ample opportunities for dramatic effects. Keep your use of contour line to a minimum. Use it only in discrete places as a very subtle accent. Most of the form should be defined by the edges created by the transitions between light to shadow. Add some limited details and softer descriptive values within the light side of the form.

Chiaroscuro

The lost-and-found idea is not new. Caravaggio, a Baroque painter, used this concept to give a sense of drama to his work. *Chiaroscuro*, meaning light and shadow, is the term associated with such dramatic, highly contrasting tonal effects. In this approach, the darks basically melt into the background, allowing the subject to emerge out of a dark void.

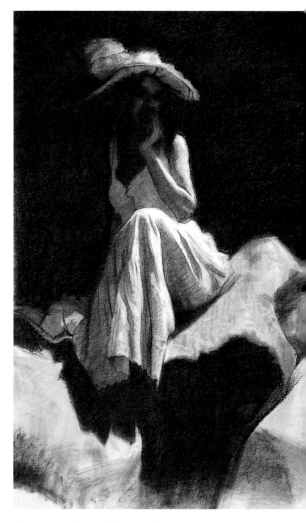

Use Lost and Found Edges to Create a Dramatic Effect
The contrast of strong black and white creates drama as this figure almost emerges from the deep shadows of the background. I used mid-tones and lights to clarify the details.

White on the Rocks
Charcoal on artists' vellum
24" × 18" (61cm × 46cm)

Adding Tonal Accents

Including tonal accents can add excitement to a drawing. You might choose to add a spot of color or a simple value. Many of the drawings exhibited in this book thus far employ tonal accents. These may indicate local tone, create lighting or reveal form. Tonal accents can also help emphasize a focal point.

Choosing exactly where to place a tone or how much tone to use is a matter of personal preference. With experience, your ability to decide when you use tonal accents will increase. Initially, think of less as more. Add tone only if you feel it is necessary.

Less Can Be More
The very simple, understated line drawing is accented by adding tone in the dead and minimal shadow on the left, then smearing it with a brush and turpentine.

Wise
Oil pastel on box board
18" × 12" (46cm × 30cm)

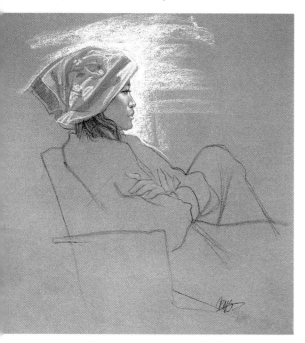

Use Tone to Establish a Drawing's Focus
I added tonal accents to the young girl's scarf along with a white accent behind her face to make her profile the focus of this piece.

A Patterned Scarf
Charcoal and Conté on toned Canson paper
20" × 18" (51cm × 46cm)

Aesthetic Marks

Aesthetic marking means varying the nature of your marks to better capture the subject. Aesthetic marking is often overlooked or taken for granted by many artists because they are usually more concerned with accuracy. However, it is marks that make up the image, so one must consider of how those marks are made and how they affect the drawing style.

Aesthetic marks may be made with a variety of tools and can take many forms. Aesthetic marks may be careful and refined, casual and spontaneous, powerful and bold, soft and sensitive, fluid and curvy or sharp and straight. One mark may gradually change from dark to light or thick to thin. Some variations of aesthetic marks, such as quick curving or looping lines, may be used to add tone or develop form. Experiment with different types of aesthetic marks to find the drawing style that expresses your ideas.

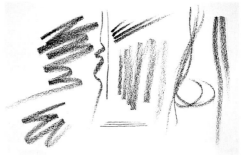

One Medium Can Create a Variety of Aesthetic Marks
A variety of marks from careful and crisp to rapid and soft are shown here. The medium is a 6B charcoal pencil.

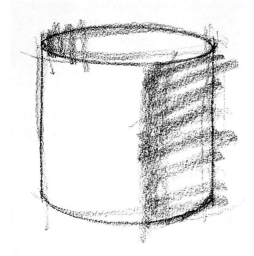

Aesthetic Marks Can Be Used for Toning and Suggesting Form
This quick, abbreviated drawing of a cylinder uses crisp control lines on the contours and broad soft marks to suggest the form shadow.

Local Tone

Local tone refers to the basic value or color of an element, independent of value variations used to model the subject with light and shadow. Every subject has a local tone: a black coat, a white shirt, a gray tie, dark hair or medium-light skin.

Although the line work may stand on its own, the addition of a few, well-placed local tones can give snap and vitality to the drawing.

Be selective when adding local tones or you will overwhelm your focal point. Local tones may be flat and graphic, or they may have a loose texture. This is a stylistic choice that often depends upon the drawing medium, so don't be afraid to use a different medium to get the effect you want.

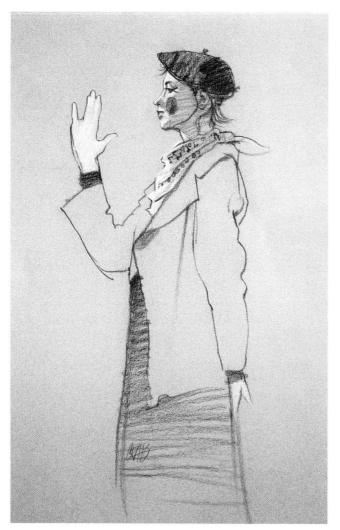

Add Local Tones to Your Drawing
The lights and darks in this drawing have more to do with local tones than with modeling with light and shadow: a dark hat, a white glove, a medium coat and a darker skirt.

Part-Time Mime
Black and white charcoal on gray Canson paper
18" × 24" (46cm × 61cm)

Combining Line and Tone

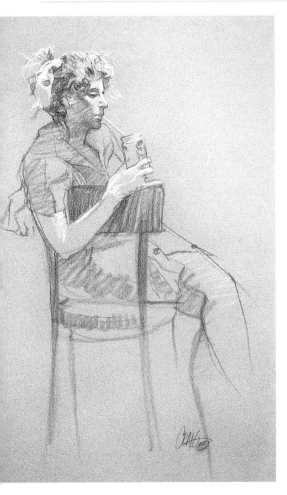

Using line and tone together gives a special quality to a drawing. A fully toned drawing exhibits a unique sense of unity. Pieces that combine line and tone, however, invite the viewer to take part in the drawing process.

The relationship of line to tone in a drawing may be one to one, or either may take a subordinate role. Your aesthetic sense—or perhaps the amount of time you're willing to spend on the project—will be the determining factor for this relationship.

Most mediums or medium combinations can work well together. Hard line and ink wash work effectively together, as do charcoal and pastel or graphite and watercolor. Some of the enjoyment of line-and tone-drawings lies in discovering the ratio of line to tone that you like and the medium or mediums that feel right to you.

Determining Line and Tone Relationships
The time frame helped dictate the line-to-tone ratio in this drawing. The model posed for only twenty minutes so limited tones accent the loose line drawing.

Break for the Waitress
Black and white charcoal on gray Canson paper
18" × 24" (46cm × 61cm)

Style

Your drawing style results from a combination of your mind and the medium. Of course, the medium you choose will dictate certain aspects of your style. For example, your work will undoubtedly include more hard, crisp lines and stark value contrasts if you use a black ink pen than if you use pastels, but it is what goes on in your mind that really determines how your drawing will look. What is your intent? What you plan to achieve with a medium? Do you want to express freedom, or exercise control? Do you hope to capture a moment or to develop discipline? What are your personal tastes?

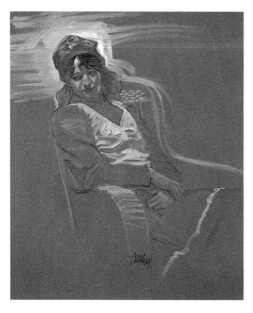

Medium and Style
This mixed-media sketch uses color and the tone of the paper as value variations.

Marie
Charcoal, oil and oil pastel on toned Canson paper
22" × 17" (56cm × 43cm)

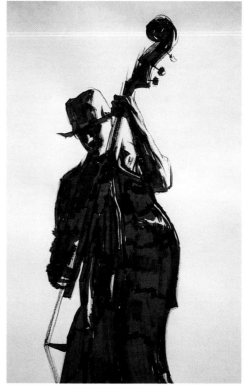

Intent and Style
This loose, graphic brush drawing employs a silhouette effect with a touch of light from behind right. The intent here was to focus on the essential shape only. Learning to edit out detail can be a challenging exercise.

The Bass Fiddle
India ink brush and oil pastel on white artists' vellum
22" × 17" (56cm × 43cm)

Style and Intent

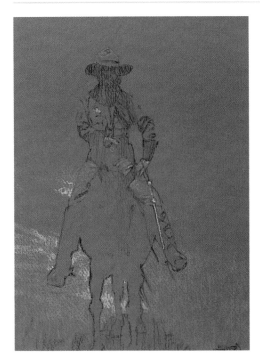

A Minimalist Approach
How much can be said with very little? This image contains a lot of empty space, but a minimum of outline and tone can say a lot if used carefully. Planning ahead and not overdoing are the keys to this minimalist approach.

On Horseback
Pastel on toned Canson paper
14" × 11" (36cm × 28cm)

Do you prefer symmetry or asymmetry? Simplicity or complexity? Are you mostly interested in people, places or things? What are your thought processes? Do you see and think in linear patterns, or in more tonal or graphic ways? The answers to these questions will determine your personal style.

One aspect of style to avoid is gimmickry. Do not force a style by using methods or including faddish characteristics that feel unnatural or uncomfortable. Your drawing should not be about the style; it should be about you and what you wish to convey. Experiment, but with integrity. Your style is part of who you are.

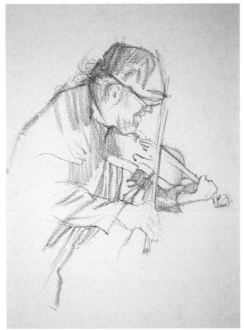

Use Style to Convey Intent
The basic intent behind this quick sketch was to underplay detail, using sketchy, earth-toned lines of varied weights to help create energy.

Fiddler
Conté pencils on toned Canson paper
14" × 11" (36cm × 28cm)

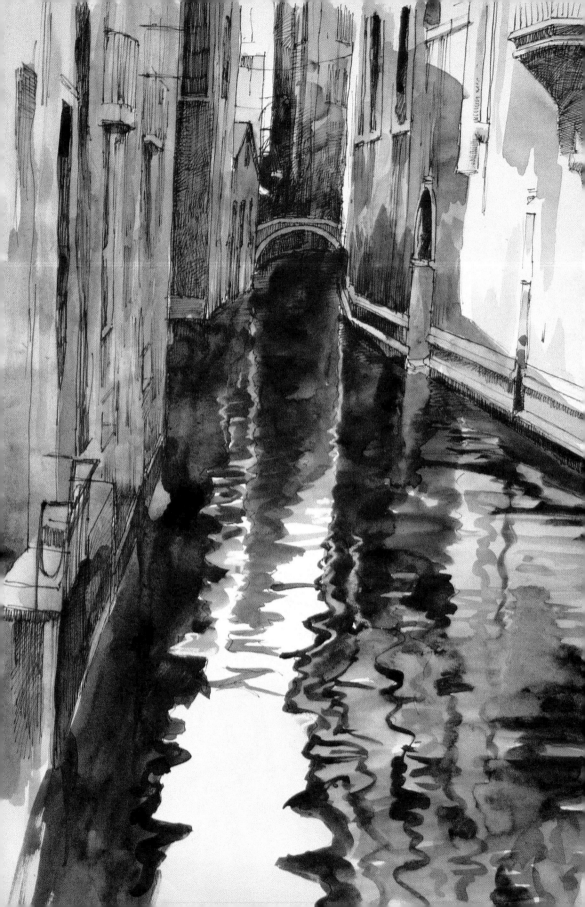

PERSPECTIVE AND PROPORTION

Perspective and proportion are important principles of drawing because they add authenticity to your work. Trying to draw perspective and proportion accurately can be a daunting task if you don't fully understand these concepts. This chapter is intended to help you strengthen your knowledge of perspective and proportion and to provide you with techniques to incorporate them successfully.

Venetian Alley
Pen and watercolor on hot-pressed watercolor paper
15" × 10" (38cm × 25cm)

What Is Perspective?

Perspective is one of the most important principles of drawing. It gives authenticity, depth and dimension to a composition. The concept of perspective is simple: Objects of the same size appear larger when they are closer to the viewer and progressively smaller as they recede farther in space. Perspective is most easily seen in rectangular forms such as cubes, houses and buildings. Repetitive forms that advance or recede, such as rows of windows, poles, automobiles, cups or cans, all show perspective, their sizes diminishing as they go back in space. As elements recede into the distance, they converge toward what is referred to as the *vanishing point* on the *horizon line.* The horizon line is usually placed at eye level, which will vary depending on the height and location of the viewer.

Perspective in drawing is classified into three basic types: one-point perspective, two-point perspective and three-point perspective. Artists must check and double-check the accuracy of their rendering. Since all elements in a composition must relate to each other accurately in perspective, the more elements a drawing contains, the more challenging it will be to achieve convincing perspective.

Much about perspective is geometric in concept and mechanical in plotting, but used aesthetically as well as accurately, it gives a wonderful and necessary authenticity to any scene.

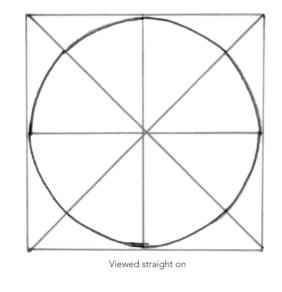

An Ellipse in Perspective
A circle becomes an ellipse when viewed in perspective. Notice how the ellipse appears to recede into the distance when viewed at an angle.

Viewed straight on

Viewed at an angle

Point of View

Basically, point of view is the position or angle from which an object is seen. Point of view is important to consider as you use perspective because it will help you effectively create the illusion of depth. The artist must establish the point of view of a composition before attempting to show depth through the use of perspective.

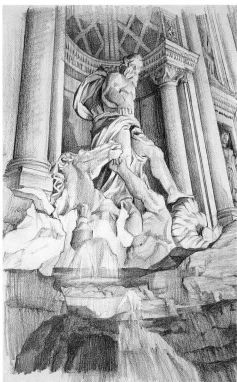

Worm's-Eye View
This sketchbook drawing depicts a low point of view sometimes called a worm's-eye view.

A View of Trevi Fountain
Graphite on sketchbook paper
12" × 8" (30cm × 20cm)

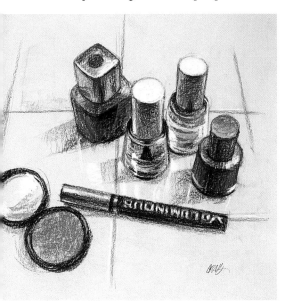

Bird's-Eye View
This pastel sketch has a high point of view, with the viewer looking down on the scene. This type of perspective is sometimes called a bird's-eye view.

Makeup and Goodies
Pastel and Conté on drawing paper
14" × 14" (36cm × 36cm)

Plan Before You Draw

Determine the type of perspective you will use before you begin drawing. You don't have to plot out your composition exactly, but you should begin with a general idea so you know where in your composition perspective will be used the most.

Using Depth to Show Perspective

When using perspective, remember that the sizes of objects in the distance must become smaller. Vertical lines remain vertical, but horizontal lines become angled as they recede and converge toward the horizon line, whether or not you perceive the change. The illusion of depth is enhanced with overlapping forms.

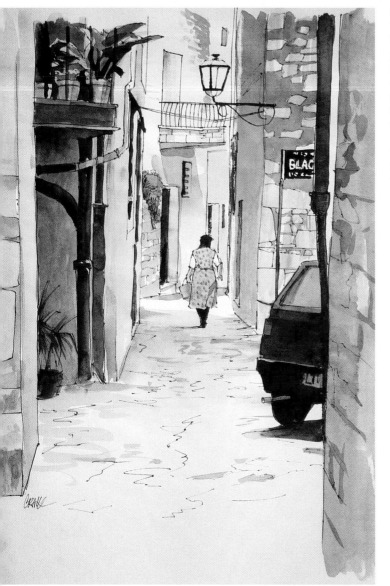

Create a Sense of Depth
This wash drawing demonstrates how the combination of overlapping forms, converging lines and scale change can create a sense of depth. The large, bold foreground elements are set off by the more distant elements as well as the background figure.

The Narrow Street
Pen-and-ink on bristol board
14" × 11" (36cm × 28cm)

One-Point Perspective

One-point perspective is the simplest and most basic form of perspective. It may be employed when the viewer is looking at objects within a scene straight on. The technique uses only one vanishing point, with all receding horizontal lines converging at one place in the distance. All nonreceding horizontal lines are parallel to the picture plane and therefore are truly horizontal. One-point perspective is perhaps best illustrated by looking down a long hallway. It is obvious that ceiling lines, or *base lines*, all converge towards one common point. By adding dramatic lighting to a drawing with one-point perspective you can create a great impact.

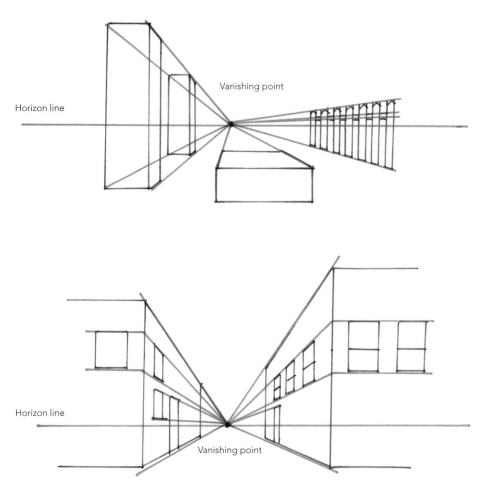

One-Point Perspective Diagrams
These one-point-perspective diagrams illustrate the basic principle of the single vanishing point.

Two-Point Perspective

Because we generally view objects within scenes at an angle rather than head on, we usually tend to see things in two-point perspective. As the name suggests, this type of perspective includes two vanishing points. All horizontal lines will seem to converge toward one point or the other, depending on the angle from which they are seen.

There may be multiple two-point perspectives again depending on the viewing angle.

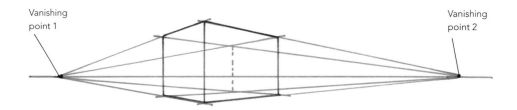

One Form, Different Two-Point Perspectives
This diagram shows a cubic form as seen from two points of view, with two-point perspective applied.

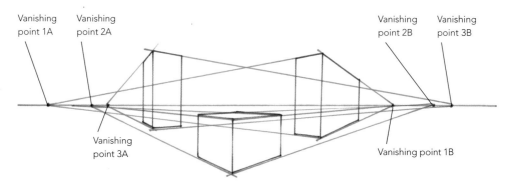

Many Forms, Two-Point Perspective
This diagram shows multiple forms viewed at different angles with two-point perspective applied.

Three-Point Perspective

Three-point perspective is employed when the viewer is looking either up or down at a subject. Whereas one- and two-point perspective involve horizontal lines, three-point perspective involves vertical lines that converge at a third vanishing point. If the viewer is looking up, the vertical lines will converge above eye level; if looking down, they will converge below eye level.

Think of gazing up at a very tall building. The verticals of the long rectangular forms will converge upwards. If, on the other hand, you are gazing down from the top of that tall building, those same verticals will converge downward.

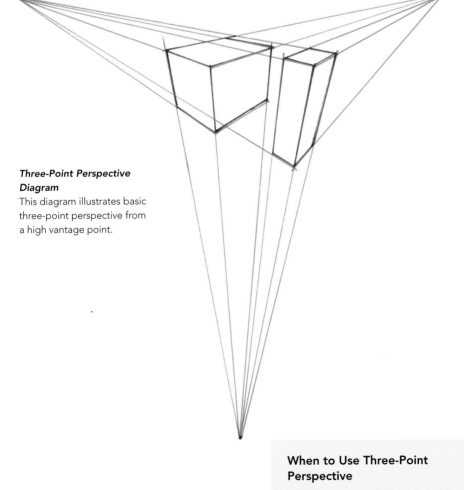

Three-Point Perspective Diagram
This diagram illustrates basic three-point perspective from a high vantage point.

When to Use Three-Point Perspective

Three-point perspective is required when the scene is being viewed from either a high vantage point or a low one. Be sure to consider the viewer's eye level in relation to the forms you want to depict.

What Is Proportion?

Creating an accurate drawing depends upon a true understanding and interpretation of proportion. Simply stated, *proportion* is nothing more than a size relationship. Perhaps the easiest way to begin learning about proportion is to think of a 12-inch ruler. An object that is half as long as the ruler is six inches; one three-quarters or 75 percent of that length would be eight inches. Calculating measurements is an easy, mechanical way of dealing with proportions. However, an artist must learn to observe and deal with proportions in a more subtle and sensitive manner when exact measurements are not so easily determined.

Use Visual Markers to Render Proportion Accurately

Here I used such visual markers as the folds in my subject's clothes and the position of her body in the chair to achieve accurate proportions in the drawing.

One Cool Outfit

Charcoal, Conté and white chalk on toned Canson paper
18" × 24" (46cm × 61cm)

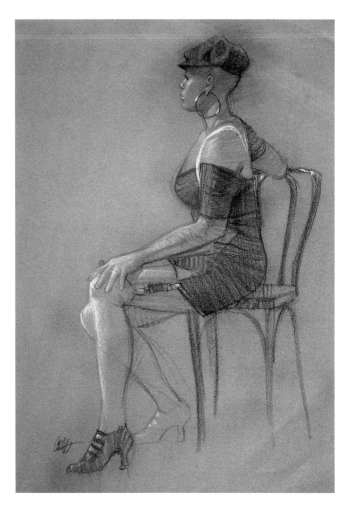

Find points or "landmarks" that you can use to relate the size of one shape to another. For example, at what point does the handle intersect the side of the mug? Is it three-fourths of the way up, or closer to five-eighths? Practice and repetition will improve your ability to render proportions correctly. Training your eye to estimate and compare measurements will also increase your sensitivity to subtleties.

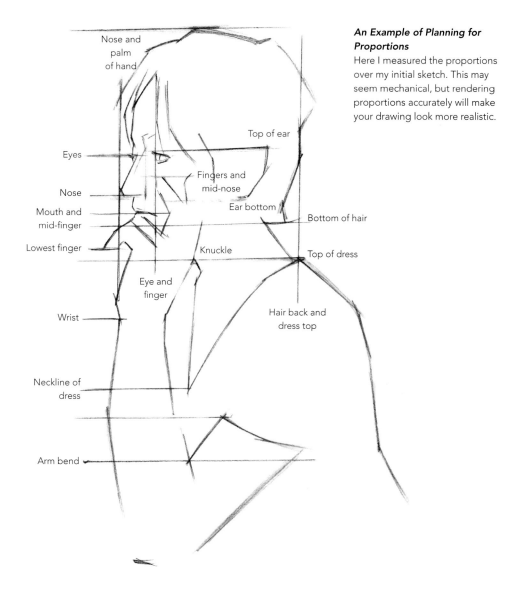

An Example of Planning for Proportions
Here I measured the proportions over my initial sketch. This may seem mechanical, but rendering proportions accurately will make your drawing look more realistic.

Nose and palm of hand

Top of ear

Eyes

Fingers and mid-nose

Nose

Ear bottom

Mouth and mid-finger

Bottom of hair

Lowest finger

Knuckle

Top of dress

Eye and finger

Wrist

Hair back and dress top

Neckline of dress

Arm bend

Using Tick Marks

You may find it helpful to use *tick marks* to indicate distances. Tick marks are tiny marks you draw on your paper to indicate a visual landmark that you use to map out other visual landmarks as you draw. This is preferable to just eyeballing the distance and assuming you are correct. Tick marks help you create a basic diagram or structure for your drawing.

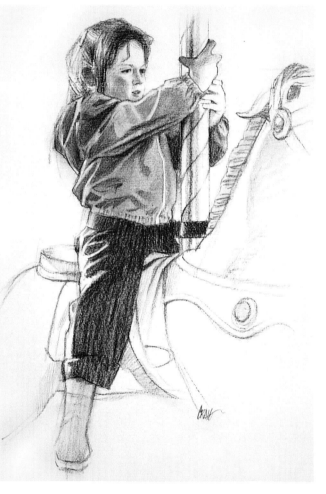

Diagram With Tick Marks
This diagram of tick marks shows how they establish the key points for your drawing.

Fill in the Tick Marks to Complete the Drawing
Once you've mapped out the proportions with tick marks, the details are much easier to add. Be sure to include your subject's environment in your tick mark diagram. The subject's environment provides additional reference points for measuring to achieve correct proportions.

The Young Horse Woman
Charcoal on bond paper
10" × 14" (25cm × 36cm)

Using Size Relationships

Careful observation of size relationships is another way to achieve correct proportions. Compare the heights and widths of various objects and note the differences with tic marks before proceeding to the drawing or painting stage.

Practice Establishing Size Relationships with Still Lifes

Still lifes are great for practicing this technique. It is easy to find objects of various sizes to set up in the studio.

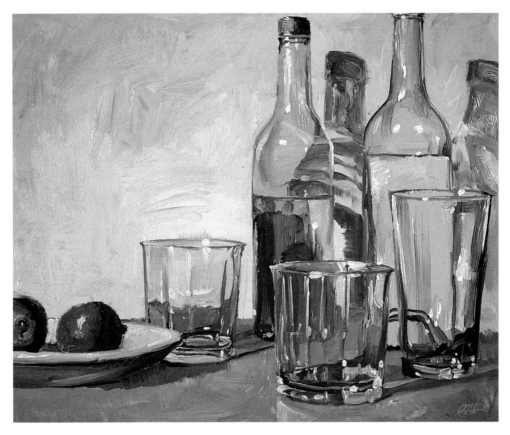

Size Relationships Are Important
Although this is a loose oil sketch, the size relationships—both height and width—must be accurate for the composition to be successful. The sizes and shapes of this collection of glassware and fruit are relatively simple, but they create an interesting arrangement.

Glasses and Limes
Oil sketch on gessoed Masonite panel
20" × 24" (51cm × 61cm)

Using a Grid

A great tool for figuring out proportions is a grid. A grid will help you find the center of a composition and subdivide it into quadrants or even smaller sections. Such subdivisions establish points to help you correctly locate elements of your subject within the composition. Many painters use a literal grid before painting over it. For a drawing, however, a virtual grid may be indicated with light marks on the sides, top and bottom of your page.

Many artists may do small "thumbnail" sketches for design, composition or content.

Once the sketch is completed, it must be scaled up to keep its proportional integrity. Using a grid is the most accurate way to accomplish this.

On a piece of acetate, draw a grid with the same exterior dimensions as your thumbnail sketch, then divide it into quarters, eighths or even smaller units. Now indicate similar subdivisions on your drawing surface. Transfer the sketch to the larger surface square by square, matching key reference points of the subject to corresponding points on the grid.

Use a Grid to Determine Proportions
The exterior grid marks divide the picture plane into quarters. The interior cross hairs give key points to help determine proportional relationships. Note the implied center; it falls on the belt line, just to the right of the hanging sash. You may want to divide your composition into eighths, or just approximate eighths as you measure and draw.

Fashion-able
Charcoal on bond paper
18" × 24" (46cm × 61cm)

When Using Grids

A dark, literal grid is fine as long as you're going to paint over it. Otherwise, a light "virtual" grid works best.

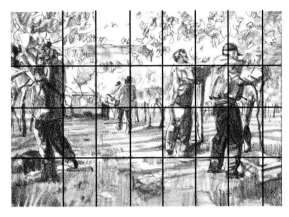

Compositional Sketch With Grid
This sketch of workers focuses on the placement of the figures and how they relate to the vineyard. With the grid on top, you can see how the relate to the cross points, horizontals and verticals.

Workers
Fine-point pen and charcoal on vellum
5½" × 7½" (14cm × 19cm)

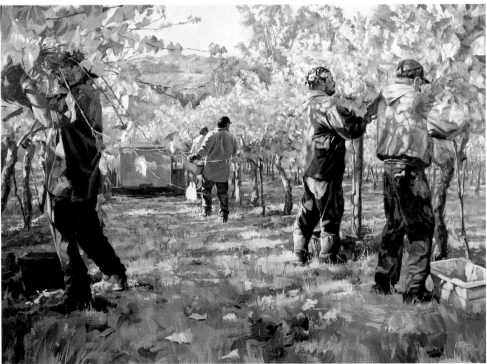

Using Visual Landmarks

Proportion is all about measuring and comparing. When measuring, look for key reference points or *visual landmarks* on your subject. These may include sharp angle changes such as corners, or distinct tonal changes between shapes such as pieces of clothing. The intersection of two lines makes a great visual landmark.

Another measuring device that will help you place elements correctly is alignment. Notice when one element in a composition lines up with another. Usually vertical or horizontal alignments work best.

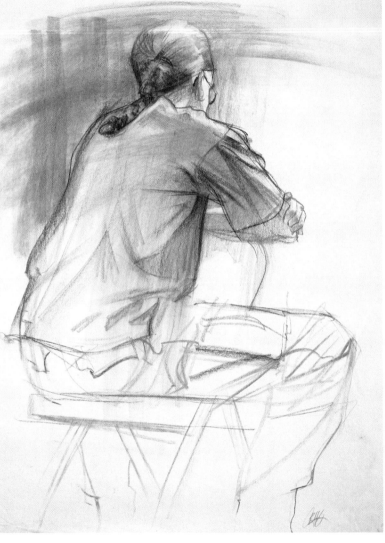

Use Visual Landmarks
This three-quarters back view includes a variety of visual landmarks that make checking proportions easier. The many folds are extremely useful.

Back Again
Conté on bond paper
17" × 22"
(43cm × 56cm)

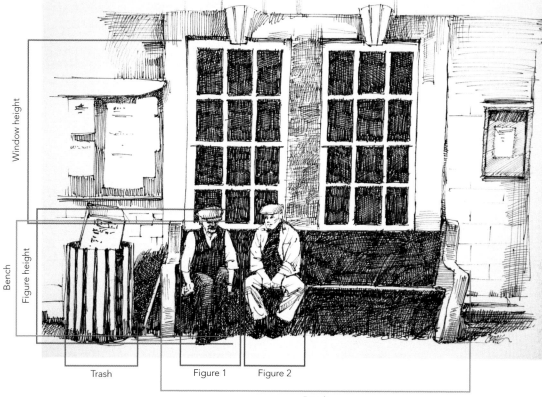

Window height

Bench

Figure height

Bench

Trash

Figure 1

Figure 2

Bench

Diagram of Proportions

The more elements in a composition, the more visual landmarks there are. I simplified the task of determining the proportional relationships in this piece by mapping out the proportional break up of space.

Friends

Ultra-fine-point pen on bristol board
8" × 12" (20cm × 30cm)

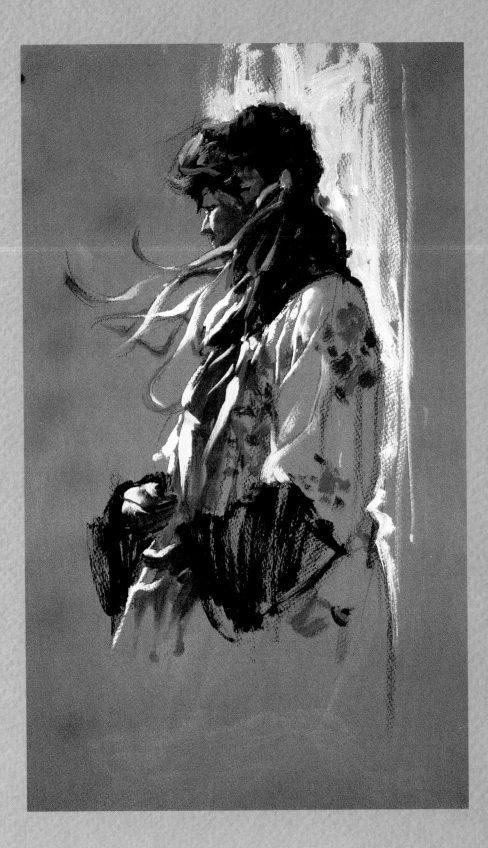

Drawings as Preliminary Studies and as Finished Art

Artists draw for many reasons. Many do it purely as a form of recreation or relaxation. Some draw for practice, so that they may continually improve. Artists who work in other mediums such as painting and sculpture draw studies to help them plan compositions and work out problems before beginning a larger piece. Others find satisfaction in producing a drawing as a finished work of art.

Flowing Ribbons
Charcoal and oil on toned mat board
17" × 12" (43cm × 30cm)

Preliminary Studies and Sketches

Many drawings are created as preliminary studies for a painting. Others may be sketched directly on the canvas as a foundation for the painting to be completed on top.

Preliminary drawings usually focus on a particular principle or problem. They may concentrate on value patterns or lighting issues.

They may be concerned with proportions, perspective or the placement of elements within the frame. They allow the artist to experiment with different formats before committing to a specific surface. Preliminary studies are often smaller than the final work so that they may be done more quickly.

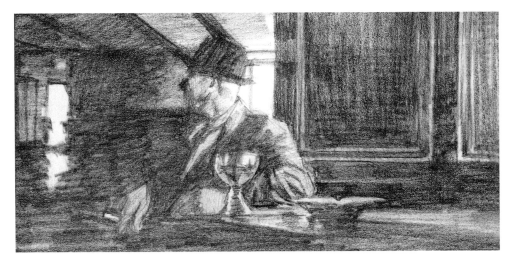

Value Sketch for Morning Reisling
This is a quick charcoal sketch I did to develop value pattern and compositional content.

Reisling Sketch
Charcoal on vellum
4½" × 9" (11cm × 23cm)

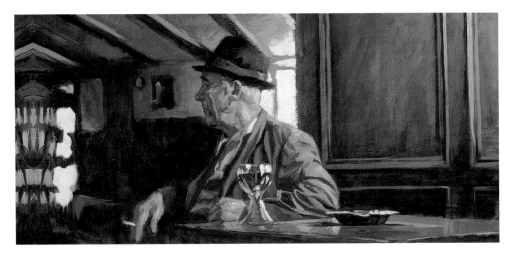

Final Painting
Since I had already addressed issues of design and value in the sketch, I was free to explore the warm indoor palette I used for my finished painting.

Morning Reisling
Oil on panel
15" × 30" (38cm × 76cm)

Sketch to Solve Problems

Preliminary sketches do not have to be detailed, and they don't even have to be entirely accurate. It may be enough for your sketch to roughly establish the shape and placement of major forms if you plan to work out the exact proportions and measurements on the final surface itself.

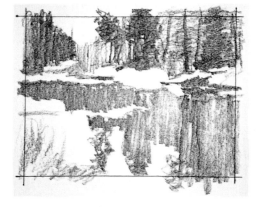

Composition Sketch
Darks, midtones and lights create this composition of tonal shapes representing trees, water and brush.

Landscape Reflections Sketch
Graphite on ledger paper
5" × 7" (13cm × 18cm)

Value Sketch
A pattern of lights, darks and a few midtones establishes the values for this sketch done with simple tones and shapes.

Teton Elk Sketch
Graphite on vellum
5" × 7" (13cm × 18cm)

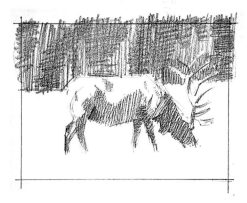

Sketch of Perspective
Perspective is the basis for this architectural sketch. Shadows define the structure of the value pattern.

Structure of Light and Shadow Sketch
Graphite on ledger paper
5" × 7" (13cm × 18cm)

Rough Sketches

The purpose behind a rough sketch is to try out a compositional idea before committing to a more finished piece of art. The scale of rough sketches may be quite small, just big enough to allow the artist to get an idea of how to balance forms and values. Rough sketches also give the artist an opportunity to explore options without investing a great deal of time or wasting expensive materials.

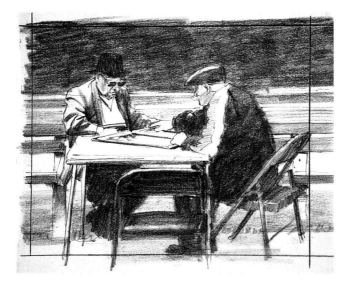

Rough Sketch for It's Your Move

I drew a quick line sketch with ink to try out the placement of different elements. I used loose charcoal tones to indicate the values. While I sketched, I simplified the background so it would contrast with the foreground activity.

Players

Fine-line pen and charcoal on vellum
8" × 10" (20cm × 25cm)

Sketches Save Time and Energy During Painting

When I began to paint, I followed the value patterns and simplified background I had worked out in the sketch, making only subtle adjustments. The colors, edges and brushwork became my primary concerns.

It's Your Move

Oil on canvas
24" × 30" (61cm × 76cm)

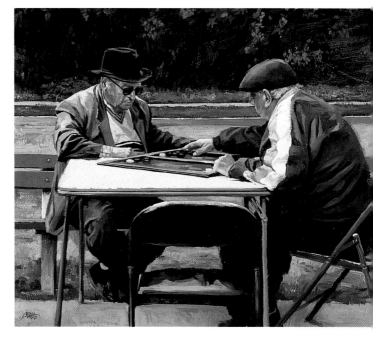

Reference Sketches

Reference sketches provide an artist with resources to consult during the production of a painting. They are often drawn from life or from a model to help the artist render a more realistic gesture or pose. For example, reference sketches capturing the motions of a trotting horse can help the artist accurately portray that movement in the finished work. A reference sketch done on location can serve as a guide for work to be completed in the studio. Problems

Reference Sketches Resolve Many Questions

Perspective usually is a major concern when drawing architecture, so it's a good idea to do a rough sketch first. In this sketch I used pastels to help me decide on a color palette for the painting as well as to work out the perspective.

Venetian Scene Sketch
Pastel on Canson paper
11" × 14" (28cm × 36cm)

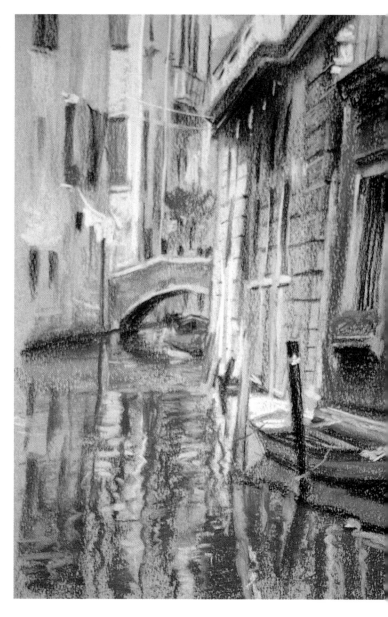

of proportions and perspective may be resolved in carefully calculated reference sketches so that the artist doesn't have to stop and figure them out during the painting process. Reference sketches also allow the artist to focus on only one small area of a subject that may be particularly demanding so that he can get the details right before trying to depict them with paint.

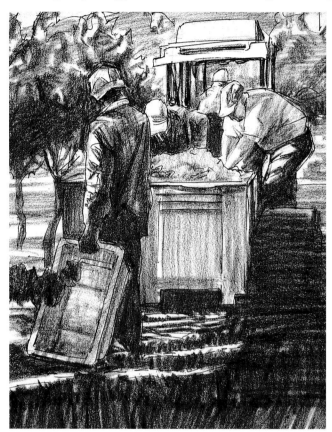

Establish a Painting's Composition in a Reference Sketch
Complex, active compositions can be more easily worked out in a small sketch prior to completing a larger painting.

Working in the Vineyard
Ink and charcoal on vellum
9" × 12" (23cm × 30cm)

Drawings as Finished Art

When is a piece of art finished? This question can be answered only by the artist, because only the artist knows exactly what she is striving to achieve. To arrive at an answer for any particular piece, the artist might ask:

- Does it meet my quality standards?
- Does it accomplish what I set out to do?
- Is there any way I can improve it?
- Am I satisfied with it?

Deciding when a piece is finished is a judgement call that depends on the style and sensibilities of the artist. What one artist calls complete may seem lacking—or perhaps overworked—to another, no matter what the medium. You must be the judge of your own work.

Sometimes it may be helpful to leave a piece alone for awhile. Allow yourself some time and distance from the work before deciding whether it is truly done so that your evaluation can be more objective.

Even drawings that are very simple and abbreviated can be considered "finished" if you are satisfied with them. A mat or frame may be all that's needed to provide that "finishing touch."

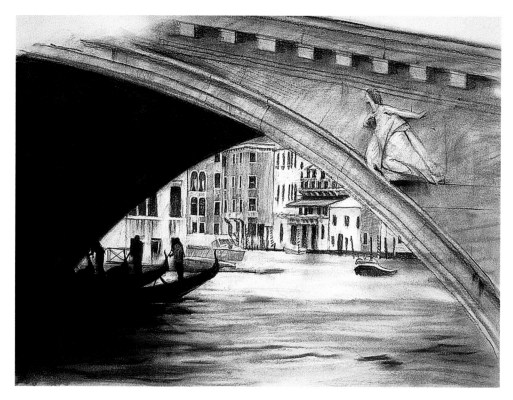

The Artist Determines When the Work is "Finished"
This charcoal drawing is obviously a finished piece. The varied values, covering the full range from rich darks to soft, light grays, produce a work with enough detail to feel complete.

Below the Rialto
Charcoal on artist's vellum
13" × 18" (33cm × 46cm)

Refining a Drawing

Final, refining touches are those additions or corrections that turn an adequate drawing into a truly satisfying one. They can take various forms, depending on the style of the drawing and the artist's intent. For example, a light tonal wash may be just the right final touch for a simple line drawing. A pastel sketch may benefit from some more colorful accents or deeper contrasting shadows. Perhaps more highlights need to be lifted from a charcoal drawing, or the facial features in a pencil sketch could be more carefully defined. Practice and experience will refine your ability to recognize the needs of your drawing and make those final aesthetic decisions.

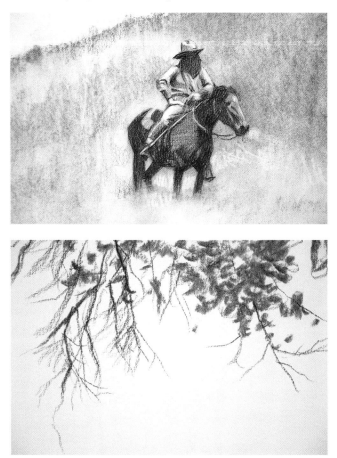

Detail of Lone Rider
The crisp edges and strong tones of the rider contrasts with the softer, smeared weeds in the field through which he is riding. I added greater definition to draw the eye toward the figure, which is the focal point.

Notice the casual way in which the tree branches have been rendered. Masses of leaves have been indicated with a piece of soft vine charcoal.

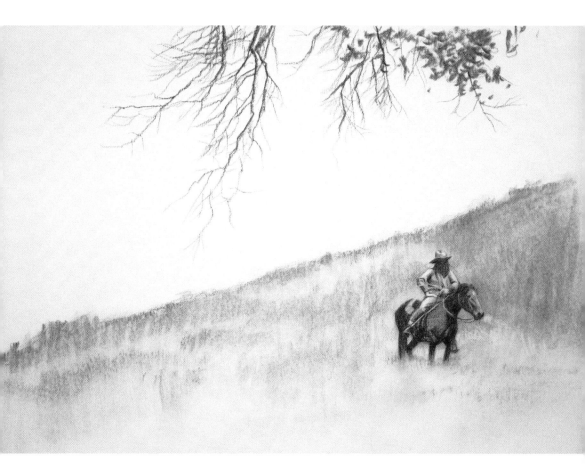

A Refined Drawing
I wanted to evoke a feeling of loneliness in this drawing, so I placed the figure within the composition accordingly. I also employed a full range of values and varied edges to create a feeling of spaciousness.

Lone Rider
Charcoal on artist's vellum
18" × 11" (46cm × 28cm)

Matting

The placement of a mat around a drawing makes it appear more complete. A mat helps to focus the viewers' eyes on the art and away from what is around it, emphasizing its significance. A mat is generally about 2½ (64mm) to 4 inches (102mm) in width and ½-inch (13cm) longer on the bottom.

The color of the mat should not detract from your art. When in doubt, keep it relatively neutral. Black or white may be too harsh, but on certain pieces either might be very effective. Fabric such as linen may be stretched over the mat for a more elegant presentation. A fillet, a narrow (¼-inch to ⅜-inch [6mm to 10mm]) mat in a

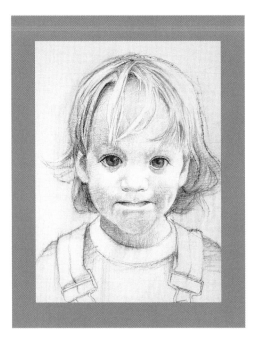

Use the Right Mat For Your Art
If you were going to frame the drawing *Ian's Eye's,* which mat would you choose?

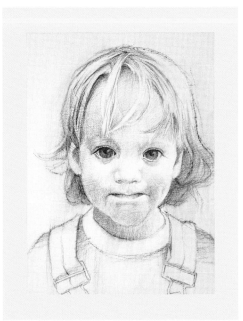

Choosing a Mat for a Color Drawing

If the drawing is in color choose a compatible color for the mat so that it doesn't overwhelm the picture. The fillet can pick up a contrasting tone from the artwork.

contrasting color, can provide an accent between the mat and the art. You can cut mats yourself or have them done by a professional framer, although the latter will cost quite a bit more. For longevity, choose acid-free matting materials.

Take the Worry Out of Choosing a Mat

Take the time to look at the mats used on other people's drawings. This will give you an idea of what kind of mat would work for your artwork.

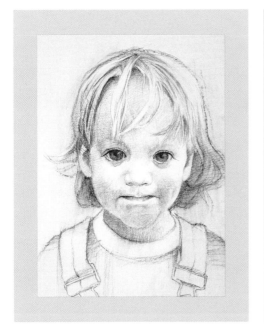

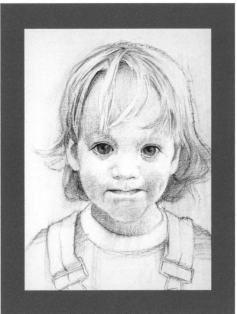

Framing

The final stage in presenting your art for exhibition or display is framing. Frames come in various colors, finishes, textures and styles to suit any type of artwork. Selecting a frame is a matter of personal taste, but I think it's best to not overdo the framing. I prefer frames that are narrower than the mat so the artwork remains the focus.

The glass used in framing is also important. It protects the artwork and adds a nice surface finish. The mat keeps the glass from touching or rubbing against the surface of the artwork so you don't have to worry about smearing or other damage. Glass options include traditional plate glass and Plexiglas; both come in nonglare versions. If you're going to exhibit your work, Plexiglas is the rule for most shows.

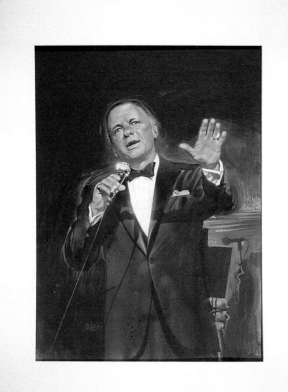

Unframed, Matted Art
An off-white mat helps complete this mixed-media portrait, complementing the white shirt in the art.

Sinatra
Acrylic and mixed-media on cold-pressed illustration board
22" × 16" (56cm × 41cm)

Conclusion

With its variety of mediums, surfaces and approaches, and with endless possibilities for subjects, drawing offers a lifetime of stimulating challenges. Whether in classes and workshops or through personal study, nearly every artist has explored the richness of this art form, developing personal techniques and styles along the way.

Drawing should be enjoyable, not painful. If it ever begins to feel monotonous, simply switch to a different medium or try a new technique. Drawing can be a form of recreation as well as a means of practicing skills and studying visual concepts. Whether you draw for relaxation or professional exhibition, or even if you draw primarily to prepare for painting, don't forget that drawing can be a very satisfying end in itself.

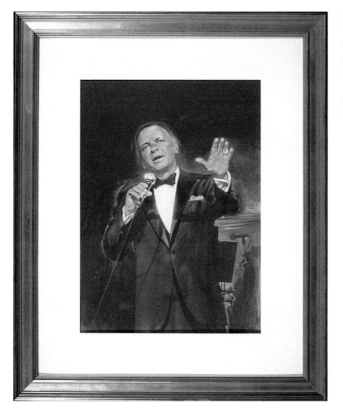

Framed Art
The mat color and frame style should not detract from or overpower the art. The glass finishes and protects the image.

Sinatra
30" × 24" (76cm × 61cm) with frame

Index

 Other fine North Light Books are available from your favorite bookstore, art supply store or online supplier. Visit our website at www. fwmedia.com.

15 14 13 12 11 5 4 3 2 1

DISTRIBUTED IN CANADA BY FRASER DIRECT
100 Armstrong Avenue
Georgetown, ON, Canada L7G 5S4
Tel: (905) 877-4411

DISTRIBUTED IN THE U.K. AND EUROPE
BY F&W MEDIA INTERNATIONAL, LTD
Brunel House, Forde Close, Newton Abbot, TQ12 4PU, UK
Tel: (+44) 1626 323200, Fax: (+44) 1626 323319
Email: enquiries@fwmedia.com

DISTRIBUTED IN AUSTRALIA BY CAPRICORN LINK
P.O. Box 704, S. Windsor NSW, 2756 Australia
Tel: (02) 4577-3555

Cover Designed by Wendy Dunning
Interior Designed by Brian Roeth
Production coordinated by Mark Griffin

About the Author

Craig Nelson graduated with distinction from the Art Center College of Design in Los Angles, California, in 1970. He began teaching in 1974 and currently teaches painting and drawing at the Academy of Art College in San Francisco, where he is Department Director of Fine Art.

His work has appeared on many record album covers for Capitol Records, Sony and MGM. He has also painted many portraits for various stars including Natalie Cole, Neil Diamond, Rick Nelson, Sammy Davis Jr. and Loretta Lynn.

Craig has won over two-hundred awards of excellence in various national shows including being selected for the Arts for the Parks competition for the last eight years. His work can be found in several galleries throughout the United States and continues to appear in exhibitions both nationally and internationally. His paintings also appeared in the book, *Art From the Parks* (North Light Books).

Craig is a member of the Oil Painters of America, the American Society of Portrait Artists and a signature member of the California Art Club. He resides in northern California with his wife and three children.

Metric Conversion Chart

TO CONVERT	TO	MULTIPLY BY
Inches	Centimeters	2.54
Centimeters	Inches	0.4
Feet	Centimeters	30.5
Centimeters	Feet	0.03
Yards	Meters	0.9
Meters	Yards	1.1

12/12

CWMARS

Ideas. Instruction. Inspiration.

Receive FREE downloadable bonus materials when you sign up for our free newsletter at artistsnetwork.com/Newsletter_Thanks.

These and other fine North Light products are available at your favorite art & craft retailer, bookstore or online supplier. Visit our websites at artistsnetwork.com and artistsnetwork.tv.

Splash: The Best of Watercolor

The *Splash* series showcases the finest watercolor paintings being created today. A new book in the series is published every other year by North Light Books (an imprint of F+W Media) and features nearly 140 paintings by a wide variety of artists from around the world, each with instructive information about how it was achieved — including inspiration, tips and techniques.

Gallery

Passionate Brushstrokes
Rachel Rubin Wolf

Splash 10 explores "passion" through the work and words of 100 contemporary painters. With each vividly reproduced modern-day masterpiece, insightful firsthand commentary taps into the psyche of the artist to explore where their passion comes ...

Watercolor Discoveries
Rachel Rubin Wolf

Splash 9 holds its own as a visual showcase, representing some of the best work being done in watercolor today. But of course, that's only the half of it. *Splash* is much more than a pretty face. In the same open, giving spirit that ha...

GET YOUR ART IN PRINT!
Go to splashwatercolor.com for up-to-date information on all North Light competitions. Email us at bestofnorthlight@fwmedia.com to be put on our mailing list!

Follow North Light Books for the latest news, free wallpapers, free demos and chances to win FREE BOOKS!